Prodigal Son Narratives
1480–1980

Ellen G. D'Oench

Yale University Art Gallery
New Haven, Connecticut

Davison Art Center, Wesleyan University
Middletown, Connecticut

Exhibition tour

April 4–July 16, 1995
Yale University Art Gallery

August 30–October 20, 1995
Davison Art Center,
Wesleyan University

March 2–April 14, 1996
Sterling and Francine Clark Art Institute

Cover: 23 b-e. Tissot, *The Prodigal Son,* 1881,
etchings and drypoints

Foreword

This exhibition—so perfectly suited to the university art museum—is the most comprehensive ever devoted to images of the prodigal son. Inspired by the parable from the Gospel according to Saint Luke, the prints in this exhibition explore the story's rich web of moral, social, and spiritual issues: thrift and repentance, forgiveness and faith, Catholicism and Protestantism, fathers and sons. As these themes emerge and recede within the images, responding to issues of importance to changing audiences, they create a chronicle of Western thought about one's relationships with self, God, family, and society.

Though this undertaking is a joint venture of the Yale University Art Gallery and the Davison Art Center at Wesleyan University, its true origins lay in the knowledge and devoted interest of Ellen G. D'Oench, Curator of the Davison Art Center. For many years she has been studying images of the prodigal son (and the prodigal daughter). We owe her the greatest appreciation, both for her hand in the organization of this exhibition and for her splendid catalogue essay.

Even an exhibition of this modest size has the behind-the-scenes support of many. Ms. D'Oench wishes to express her gratitude to Elisabeth Hodermarsky, Assistant Curator of Prints, Drawings, and Photographs at the Yale University Art Gallery. Ms. Hodermarsky was instrumental in overseeing all aspects of the project, and contributed ideas for the text and research on the objects essential to the exhibition's realization. Her colleague, Richard S. Field, Curator of Prints, Drawings, and Photographs, supplied invaluable guidance and revisions to the catalogue's essay. The author was fortunate to receive the editorial suggestions of Robert C. Lancefield and Julia Perkins, and other contributions from Ellen Chirelstein, Robert Evren, Elizabeth Milroy, Kate Steinway, Elizabeth Swaim, Phillip Wagoner, and Arthur S. Wensinger. We are grateful to the institutions which lent works to the exhibi-

tion and to David Brooke and Raphael Fernandez at the Sterling and Francine Clark Art Institute, which is participating in the exhibition tour. We also wish to thank Susan Frankenbach, Registrar at the Yale Art Gallery, and Sloan Wilson for his sensitive and inspired catalogue design.

Finally, we are grateful for the support of the Lemberg Fund, Wesleyan University, and Mrs. Carl L. Selden, whose death on the first of this year marks the end of a long and intimate relationship with the Department of Prints, Drawings, and Photographs at the Yale University Art Gallery.

We hope that our public will enjoy this exhibition as much as we have enjoyed preparing it. It is a theme with universal appeal, for the prodigal is Everyman—lusting for adventure, prone to earthly temptation, and above all longing for love and acceptance. Perhaps it is the prodigal's spirit in all of us that has drawn artists, writers, performers, and audiences to his story for hundreds of years.

Susan Vogel
The Henry J. Heinz II Director,
Yale University Art Gallery

The parable of the prodigal son

(Luke 15: 11–32, King James version)

11 And he said, A certain man had two sons:

12 And the younger of them said to his father, Father, give me the portion of goods that falleth to me. And he divided unto them his living.

13 And not many days after the younger son gathered all together, and took his journey into a far country, and there wasted his substance with riotous living.

14 And when he had spent all, there arose a mighty famine in that land; and he began to be in want.

15 And he went and joined himself to a citizen of that country; and he sent him into his fields to feed swine.

16 And he would fain have filled his belly with the husks that the swine did eat; and no man gave unto him.

17 And when he came to himself, he said, How many hired servants of my father's have bread enough and to spare, and I perish with hunger!

18 I will arise and go to my father, and will say unto him, Father, I have sinned against heaven, and before thee.

19 And am no more worthy to be called thy son: make me as one of thy hired servants.

20 And he arose, and came to his father. But when he was yet a great way off, his father saw him, and had compassion, and ran, and fell on his neck, and kissed him.

21 And the son said unto him, Father, I have sinned against heaven, and in thy sight, and am no more worthy to be called thy son.

22 But the father said to his servants, Bring forth the best robe, and put it on him; and put a ring on his hand, and shoes on his feet.

23 And bring hither the fatted calf, and kill it; and let us eat, and be merry:

24 For this my son was dead and is alive again; he was lost, and is found. And they began to be merry.

25 Now his elder son was in the field: and as he came and drew nigh to the house, he heard music and dancing.

26 And he called one of the servants, and asked what these things meant.

27 And he said unto him, Thy brother is come; and thy father hath killed the fatted calf, because he hath received him safe and sound.

28 And he was angry, and would not go in: therefore came his father out, and entreated him.

29 And he answering said to his father, Lo, these many years do I serve thee, neither transgressed I at any time thy commandment: and yet thou never gavest me a kid, that I might make merry with my friends:

30 But as soon as this thy son was come, which hath devoured thy living with harlots, thou hast killed for him the fatted calf.

31 And he said unto him, Son, thou art ever with me, and all that I have is thine.

32 It was meet that we should make merry, and be glad: for this thy brother was dead, and is alive again; and was lost, and is found.

Prodigal Son Narratives 1480–1980

1. Anonymous, *Return of the Prodigal Son*, ca. 1475, woodcut with hand coloring

The most frequently illustrated biblical parable in Western art is the story of the prodigal son (Luke 15: 11–32). By tradition, artists have chosen to represent the narrative by depicting one of the parable's two key episodes: the prodigal in penitence among swine or the prodigal welcomed back into the father's house. But from medieval times until the end of the nineteenth century, artists also found in the prodigal narrative a legend ideally suited to printed cycles of four or more scenes. Through printmakers' embellishments in serial imagery the prodigal theme encompassed a compendium of vices and virtues: extravagance and thrift, vanity and sobriety, sexual license and spiritual salvation.

This study of single-sheet prints and printed series addresses changing treatments of the prodigal theme as its popularity peaked and declined over five hundred years. From the time of an early woodcut to a photographic series of 1982, the prodigal's voyage of self discovery has offered wide latitude for interpretation. Artists used the parable primarily for religious instruction. But the parable has also served as artistic autobiography and erotic genre; as commentary on family relationships and the preservation of property; and as inspiration for narratives of pathos, of the prodigal daughter, and of redeemed or self-exiled sons.

The narrative tradition

Christ preached his parables in the gospel of St. Luke to comfort penitent sinners and the publicans, who believed themselves unworthy of redemption, and to enlighten the scribes and Pharisees who objected when Christ forgave sinners and ate with them (Luke 15: 2). As in many religions, Christian parables are fictitious narratives designed to illustrate by analogy a religious or moral truth. Thus the prodigal's

narrative—like the passages immediately preceding it in the Bible, the parables of the lost sheep and the lost coin (Luke 15: 4–10)—addresses loss and the joy of recovery. The fundamental lesson of the prodigal's story, related in twenty-two verses of descriptive prose and dialogue, teaches the prodigal's repentance and return to the father as an allegory of Christian salvation. The fatherly embrace signifies divine forgiveness of sin; the father's house is the Church, place of heavenly grace. The older brother's resentment, expressed near the end of the parable (Luke 15: 25-30), introduces an element of fraternal rivalry that artists seldom developed as a separate episode. But explanations of the older brother's response abound in exegeses by Augustine, Jerome, Erasmus, Calvin, Luther, and many other theologians who associated his self-righteous behavior with the scribes and Pharisees. They allied him with the Jews, and the prodigal son with the Gentiles, thus interpreting the message as elevating love (the New Law) over justice (the Old Law).[2]

Depictions of the parable rarely occurred before the thirteenth century, but increased thereafter in illuminated manuscripts, Bibles, and gospel texts. The narrative also appeared in thirteenth-century sculpture and stained-glass windows, such as those at the cathedrals of Troyes, Sens, Bourges, and Chartres, the latter illustrating the parable in no less than twenty-seven scenes. Similarly, narratives in four or more scenes were woven into tapestries and painted on wall hangings, furniture, and other decorative objects, testifying to the parable's ubiquitous presence among the artifacts of daily life.[3] Frequently, early prodigal narratives were populated with figures not mentioned in the Bible: male or female witnesses, and the prodigal's mother and sister.

His mother, by the mid-sixteenth century, was an especially popular figure in images and theatrical productions.[4]

Performances of *Prodigusdramen* in Germany and the Netherlands, with their expansive casts of characters, closely followed the conventions of visual cycles.[5] Among the most widely known of these stage productions were Burkard Waldis's *Der Parabell vom verlornen Sohn*, published in 1527, and the prodigal son comedy *Acolastus (Intemperate)*, published in Latin in Antwerp in 1529, and appearing in nearly fifty editions by 1585.[6] Like the European dramas, early English prodigal son plays based their interpretations not so much on theological exegesis of the parable as on representations filtered through diverse visual arts—pictures in houses, taverns, or churches, on coverlets, goblets, and chests—that "collectively established certain traditional motifs and biases."[7]

By the 1470s, publishers in the North commissioned woodcut artists to illustrate the parable in Bibles, gospels, and moralizing texts with single images, such as *Return of the Prodigal Son*, ca. 1475 (No. 1), in which the mother is witness. Appearing at the same time were woodcut sets of four and six scenes.[8] Aimed at both literate and illiterate audiences, the woodcuts drew upon a wealth of earlier visual ideas to embed the prodigal's story in the popular consciousness. Among the most expansive of the illustrated texts was Johan Meder's *Quadragesimale . . . de filio prodigo,* first published by Michael Furter in Basel in 1495, and in three subsequent editions within a short period of time. Meder's fifty sermons exemplify the common practice of preaching from the prodigal narrative during Lent. The text and sixteen woodcuts illustrate the parable as a sequence of events that mark the path from sin to penitence to salvation. In Meder's sermons, the prodigal is Everyman. Reborn through faith, he represents humanity as a witness of the Last Supper, Christ's sacrifice on Passion Sunday, the Lamentation, and Resurrection at Easter time. Throughout, Meder's prodigal is accompanied by his guardian angel who remonstrates, consoles, and rejoices as the narrative unfolds.[9] This fanciful invention attests to a vernacular tradition in literature, sermons, and images that allowed wide latitude for telling the prodigal's story.

No matter how elaborate in its exposition, the prodigal narrative was expected to center on four episodes: departure, debauch, penitence, and return. Each of the scenes illustrates the prodigal's moral condition by means of clothing, settings, and symbolic action, elements that resonate in an interplay of parallels and contrasts. In woodcuts before 1500, the prodigal receives his inheritance while standing in or outside the father's house. His richly costumed figure signifies self-delusion. Still in his finery, he gambles and drinks with venal company, seated—or sometimes dancing—with harlots inside a brothel or tavern. His inheritance spent, nearly naked in rags, he stands repentant among the swine in a field. Still ragged upon his return, he stands in contrition before his father outside the entrance to the house. Scenes of vanity and dissipation contrast with those of humiliation and remorse. Granted absolution, he exhibits the external sign of salvation by being clothed anew before he enters the father's house. These passages, by the end of the fifteenth century, telegraphed the essential elements of the prodigal son canon in drama and visual images.

Dürer's legacy

With Albrecht Dürer's engraving, *The Prodigal Son Amidst Swine*, ca. 1496 (No. 2), the narrative assumed unprecedented importance as biblical subject matter in the visual arts. The first internationally renowned artist to adopt the theme, Dürer worked his large image in the relatively precious medium of engraving, rather than woodcut, to attract discerning collectors. By exploiting the engraved line's capacity to express richly detailed textures and tones, Dürer achieved a range of coloristic values in his description of the farmyard setting, swine, and ragged prodigal. These naturalistic elements establish earthly counterpoints to the spiritual ineffability of the conversion experience. Fallen to one knee, wringing his hands while gazing at a distant steeple, the prodigal "quite literally abases himself to the level of the beasts," Erwin Panofsky has stated. "It was precisely this combination of the rustic with the emotional that won the admiration of the world."[10]

In abasing his prodigal son—having him fall down on one knee—Dürer broke with the woodcut tradition that the prodigal among swine stand on his own two feet.[11] After Dürer came the descent earthward. Only on rare occasions before the mid-eighteenth century does the prodigal stand or sit in farmyard or field; almost always he repents on one or both knees.[12] Similarly, Dürer's engraving inspired artists to adopt the kneeling posture for the prodigal upon his return to the father's house. Before Dürer, woodcuts present the returned prodigal standing up (No. 1); the only known exception to this tradition is a half-kneeling prodigal in a Netherlandish return scene dating before 1472.[13] After Dürer, and to the present day, artists have supplied audiences with this obligatory gestural convention. Whether the prodigal expresses redemption through a theatrical vocabulary of gesture, as in Guercino's *Return* of 1619 (No. 10), or through a more internalized posture of remorse, as in Rembrandt's etching of 1634 (No. 7) or Forain's etchings of 1909 (No. 26), he is inscribed with the legible sign of subservience to a higher authority.

Dürer's print and the many prodigal son images that followed in the North during the next century owed much of their great popularity to the rise of Protestantism. Dürer's interpretation of the prodigal's solitary anguish was a powerful visual expression of the notion of salvation through faith that was to become a primary tenet of Reformation theology. Many saw in the parable a means of supporting the Lutheran mission to rid the Church of mystification and symbol. Although Luther and Calvin stressed confession and repentance, they believed that salvation resulted not from churchly ritual but from God's grace alone. As Craig

2. Dürer, *The Prodigal Son Amidst Swine*, ca. 1496–97, engraving

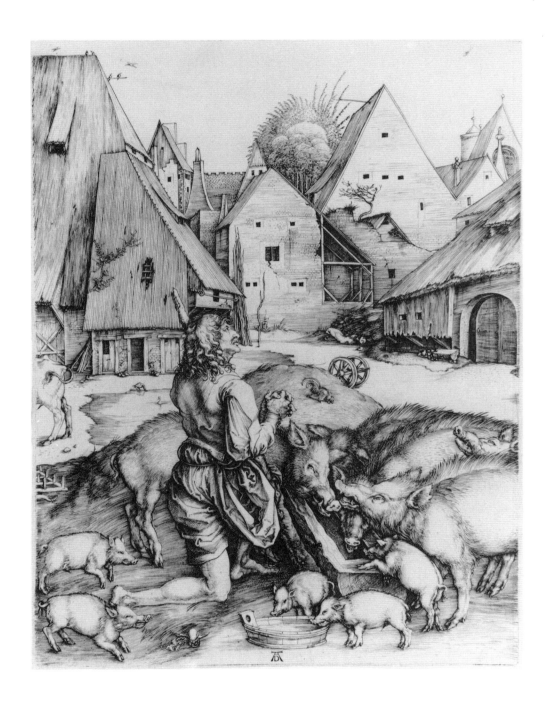

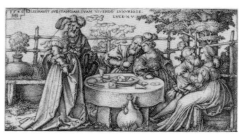

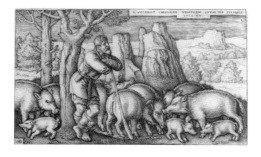

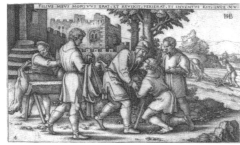

3 a–d. Beham, *The Prodigal Son,* 1540, set of 4 engravings

Harbison has pointed out, the prodigal son, "unlike his elder brother, had not gone out into the world and performed good deeds. What he had done, on the contrary, had unequivocally proved his sinful condition. Only his faith in his father's mercy and love gained him the grace and forgiveness which, according to Luther, all Christians must seek in God."[14] In her investigation of sixteenth- and seventeenth-century sermons, tracts, and dramas on the subject, Barbara Haeger has traced the clearly-stated religious differences between Catholic and Protestant theologians as to why the prodigal son was forgiven his sins. Catholics argued that "the prodigal atoned for his sins through penance, thereby meriting his father's forgiveness." Protestants, however, rejected the belief that human action must play a role in redemption, insisting that forgiveness was "not contingent upon the performance of particular acts."[15]

Despite these differences in religious beliefs expressed in texts and dramas, there is only one instance in which prodigal images made explicit visual references to sectarian allegiances. In his set of six allegorical woodcuts of the 1540s, the Protestant printmaker Cornelis Anthonisz used personifications, such as "Superstitio," and emblematic inscriptions to attack Catholic practices and sacraments. Anthonisz also maintained the Lutheran tradition of associating the older brother with both the Pharisees and the papists because of his reliance on the Law and the efficacy of works. The prodigal enters the house, the realm of grace, but his older brother, described as "Gens Judaica," remains outside.[16] The set, however, is an oddity in the prodigal canon. Typically, audiences brought their own interpretations of the parable to works of art, reading the story of an adolescent's fall from grace and redemption according to their own religious beliefs.

Giving impetus to the popularity of the prodigal son theme was its adaptation to secular interest in rustic genre subjects. From about 1510 through the second decade of the seventeenth century, numerous single-sheet engravings and serials of four to twelve scenes invited viewers to identify with the prodigal's misfortunes in taverns and brothels, or his penitence in fields and farmyards.[17] Among the immediate followers of Dürer, Lucas van Leyden borrowed the kneeling posture of the prodigal in his engraved *Return of the Prodigal Son,* ca. 1510, and associated the farm scene and rustic figures with his autonomous images of itinerant laborers, peddlers, and swineherds.[18] Similarly, Sebald Beham quoted Dürer in his single-sheet engraving, *The Prodigal Son Tending Swine,* 1538, by representing the prodigal on one knee facing a distant church. The rustic scene is related to his numerous genre images of peasants in popular culture. Returning to the theme in 1540, Beham produced in his prints for *The Prodigal Son* (No. 3) one of the earliest series executed in the medium of engraving.[19] Thus Beham reexamined a tradition begun in popular woodcut cycles that was to persist in intaglio printmaking, with interruptions, until the end of the

6

nineteenth century (No. 23). Beham's four episodes incorporate closely-observed details of costumes and settings from contemporary high and low life as the prodigal departs, feasts with prostitutes at a garden banquet, repents among swine, and kneels in the father's embrace. Prominent steps before the entrance, lacking in the first scene, now beckon the prodigal into the house. Although Beham was linked with spiritualist Reformation extremists in denying civic and church authority, he maintained patrons who held a wide range of religious beliefs within liberal and conservative Protestant or Catholic circles. Beham's representations of peasant life, whether comic or naturalistic, appealed to audiences equally diverse in social and economic status for whom rustic genre conveyed complex meanings.[20]

The tradition of mingling rusticity with religiosity persisted in engraved prodigal sets, such as that by Adriaen Collaert dating about 1588 (No. 4), in which the prodigal is a minuscule figure in relationship to his landscape setting. The prodigal as a penitent swineherd also appears as moralizing commentary in the background of engraved series illustrating times of the year or months, or in kitchen and domestic scenes.[21] Among the seventeenth-century single-sheet engravings of the prodigal among swine, for the most part reproductions of paintings, are lavishly rendered farmyard scenes, such as engravings after Abraham Bloemart and, culminating the genre tradition, by Schelte Adams Bolswert after Peter Paul Rubens' *The Prodigal Son*, ca. 1617 (Antwerp, Koninklijk Museum voor Schone Kunsten).[22] Rubens' Flemish barn, domestic animals, and agricultural implements are the dominant elements of a composition in which the prodigal is subordinated as a half-kneeling figure on the far right. Like Dürer, Rubens combined the earthly and the spiritual in the penitence scene. But his prodigal's fervent moment of right choice is a moral force in harmony with nature and the teeming bounty of farm life and production.

Dürer's engraving has been seen as the first instance of an artist identifying himself with the prodigal son. In 1604, Karel van Mander, responding to the particularized physiognomy of Dürer's prodigal, stated that the figure was actually the artist's self-portrait.[23] Similarly, although also without demonstrable evidence, Jacques Callot has been identified as the seated prodigal in the center of his dissipation scene (No. 6). That Callot did indeed associate autobiography with the narrative is indicated by the insertion of his family's coat-of-arms into two scenes from his set of ten episodes for *L'Enfant prodigue*, published posthumously in 1635.[24] An artist even more closely identified with the prodigal son is Rembrandt, whose intense preoccupation with the theme has led commentators to ally his way of life with that of the exiled wastrel, and his spiritual struggle with the prodigal's return.[25] Rembrandt's painting, *Double-Portrait of the Artist with Saskia*, ca. 1634–36 (Dresden, Gemäldegalerie), is believed to represent the artist as prodigal son in the tradition of dissipation genre.[26] Soon thereafter, he produced his etched *Return*, 1636 (No. 7), one of his most intense expressions of human anguish.[27] Rembrandt identified himself with two other biblical reformed sinners: Judas and, in a late self-portrait of 1661, the Apostle Paul. There is little doubt that Rembrandt once more drew confessional associations between himself and the prodigal when, close to death, he painted his *The Return of the Prodigal Son*, ca. 1667–69 (St. Petersburg, Hermitage Museum).[28] The prodigal theme as an expression of autobiography was to persist in texts and images throughout the following centuries.

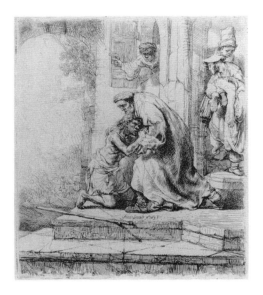

7. Rembrandt, *The Return of the Prodigal Son*, 1636, etching

"The wicked part"

The biblical account of the prodigal's actions following his departure states that he "wasted his substance with riotous living" (Luke 15: 13). Only at the end, in retrospect, does the reader learn about his dissipation more explicitly when the older brother reproaches the father for celebrating the sinner's return: "Thou never gavest me a kid that I might make merry with my friends: But as soon as this thy

son was come, which hath devoured thy living with harlots, thou hast killed for him the fatted calf" (Luke 15: 29–30). From the time of the earliest images, artists of narrative series attended closely to the brothel or tavern scene, choosing from an imaginative array of actions, characters, and settings. Prostitutes figure in no less than three of the eight scenes of the Marburg tapestry, ca. 1400–30 (Marburg, University Museum, formerly Elisabeth-kirche), in which they regale him, tend to his fleshly desires in a wooden bathtub, and expel him from the brothel.[29] In most later images, the prodigal dances or sits with prostitutes and false friends at a table stocked with food, wine, and dice or cards. Sixteenth-century settings tend to be more elaborate, whether describing the brothel's interior or its garden banquet, as in Beham's feasting scene (No. 3b). Often, professional musicians perform from a loge, and several characters may play the flute, lute, bagpipe, or fiddle, instruments widely associated with female and male sexuality (No. 5).[30] Not infrequently, a prostitute or pickpocket steals the prodigal's purse. A recurring episode in expanded cycles (made vivid in the Marburg tapestry) has the prodigal ejected from the brothel by prostitutes wielding pitchforks or brooms. Beham's woodcut from eight blocks, 1530, incorporates many of these elements and adds a large cast of characters and diverse party pleasures.[31] The viewer has difficulty singling out the prodigal as one of the men among the seven couples in the composition. But Beham intended that his presence be known, for he inserted in the background (reading from right to left) familiar episodes from the prodigal's history, including the ejection scene and the kneeling penitence and return.

Lacking these clues, Beham's image might represent any of a number of dissipation scenes that comment on the dangers in store for the generic gullible youth, not necessarily the prodigal son.[32] Unless there exists narrative quotation, as in Beham's woodcut and Jacques de Gheyn's engraving, *Prodigal Son (Allegory of Idleness and Luxury)*, 1596, after Karel van Mander, with its ejection scene in the left

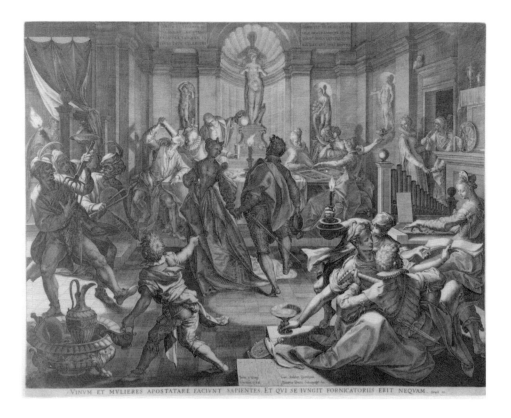

VINVM ET MVLIERES APOSTATARE FACIVNT SAPIENTES. ET QVI SE IVNGIT FORNICATORIIS ERIT NEQVAM. *Eccli. 19.*

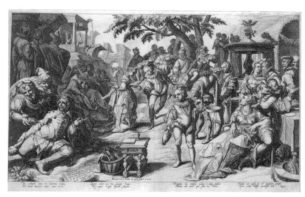

5. Sadeler, *A House of Ill-Fame (The Prodigal Son Wasting His Fortune)*, 1588, after van Winghe, engraving

Fig. 1. Jacques de Gheyn II, *The Prodigal Son (Allegory of Idleness and Luxury)*, 1596, after Karel van Mander, engraving. Gift of the Print and Drawing Club, Courtesy Museum of Fine Arts, Boston (not in exhibition)

background (Fig. 1), there is little difference between generalized prostitution and gambling images and those describing the prodigal's dissipation.[33] These distinctions become particularly obscure from the 1580s until the middle decades of the seventeenth century, a period when there was a sharp increase in the number of scenes of festivity, drinking, gambling, dancing, and music-playing among men and women in taverns, gardens, and bordellos. Establishing a genre of artistic production known as "merry company" scenes, many of these are so flamboyant in their depictions of sexual license and profligacy that commentators have regarded their interpretation in moral terms as, at the very least, ambiguous. Scenes of sinful Life Before the Flood or Life Before the Last Judgment have been interpreted as having a moralizing function related to the parable.[34] But images such as Johannes Sadeler's *House of Ill Fame*, 1588 (No. 5), send mixed signals. The Latin inscription below the image cautions: "Wine and women make [even] wise men stray, and whoever joins up with fornicators will be less than nothing." More ambiguous are the inscriptions on the plaques high in the background left and right: "Come and let us search out the good things that exist, and let us use the creatures [of the world] quickly, though [we are] in [our] youth," and: "Let no one of you be excluded from our extravagance. I will leave to be burned the signs of our pleasure, since this is our fate." The Latin text in the second state of Callot's tavern scene, ca. 1628 (No. 6), reads: "A group born in deceit surrounds the youth by means of a courtesan's cunning. On one side he is mocked in music, on the other by tricks. He loses his wealth in debauchery. Nor does he spare the reputation of his family. The prodigal drags [down] with him generous reputations."[35] Lacking this inscription, the first state of Callot's tavern scene offers no such overt moral.

From the 1580s to 1612, there flourished an unusually active production of prodigal narratives whose emphasis on the erotic pleasures of tavern and brothel offered lively, if cautionary, parallels to the

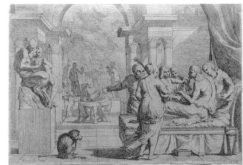
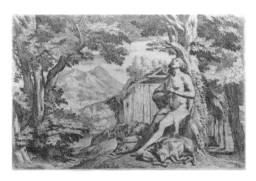
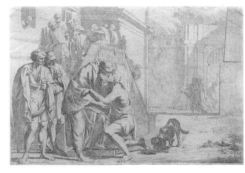

9 a–d. Testa, *History of the Prodigal Son*, ca. 1645, set of 4 etchings

merry company tradition. These included engraved sets by Julius Goltzius, Adriaen Collaert (No. 4), Jacob Matham, Crispijn van de Passe, Claes Jansz Visscher, Justus Sadeler, Johannes Gelle, and Matthaeus Merian, 1612–13.[36] Following these were the sets by Callot, 1635, Abraham Bosse, ca. 1636–40 (No. 8), Pietro Testa, ca. 1645 (No. 9), Henri Mauperché, ca. 1650–60, and Jan Baptiste de Wael, 1658.[37] During this same period, when engravers also issued many single-sheet prodigal subjects, Northern and Italian printmakers produced narratives about whores and wastrels illustrating the various temptations leading a dissolute youth to ruin.[38] These crudely-executed sets, aimed at a popular market, together with the more expensive printed serials, have been described aptly as forerunners of the modern comic-strip.[39] Narratives of prodigal sons or libertines gave artists license to produce contemporary brothel imagery well into

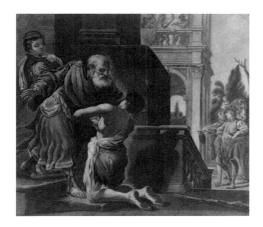

10. Gautier d'Agoty, *Return of the Prodigal Son,* ca. 1770–75, after Guercino, color mezzotint

11 a–b. Descourtis, *L'Enfant prodigue,* ca. 1795–1805, after Taunay, 2 color etchings and engravings from the set of 4

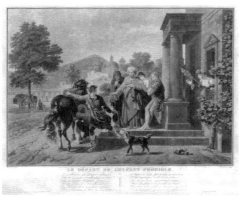

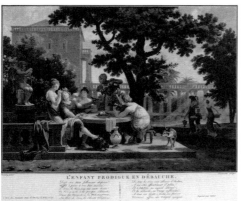

the nineteenth century, when the subject was seldom treated autonomously.

Such dissipation scenes in art and literature were granted latitude, particularly in Protestant countries, because they were situated within a moralizing story. Daniel Defoe expressed this in the preface to his 1722 saga of a prostitute, *Moll Flanders:*

As the best use is made even of the worst story, the moral 'tis hoped will keep the reader serious, even where the story will incline him to be otherwise. To give the history of a wicked life repented of, necessarily requires that the wicked part should be made as wicked as the real history of it will bear, to illustrate and give a beauty to the penitent part, which is certainly the best and brightest, if related with equal spirit and life.[40]

Defoe defends his history of a woman's folly as a means of enforcing the viewer's identification with her subsequent application to the virtuous life. At the same time, he well understood the difficulty of rendering the "penitent part" with as much spirit as the wicked. For centuries, painters and printmakers had given the prodigal's dissipation an importance in the narrative beyond that described in the Bible. Whether interpreted as instructional or erotic, brothel scenes were intended to make credible the spirit of the prodigal's redemption. For embedded in the prodigal's story was the belief that the sinner is closer to God.

Popular serials in England 1750–1800

Good counsel is never remembered nor respected till men have given their farewell to felicity and have been overwhelmed in the extremity of adversity. Young men think it a disgrace to youth to embrace the studies of age, counting their fathers fools whiles they strive to make them wise, casting that away at a cast at dice which cost their dads a year's toil, spending that in their velvets which was raked up in a russet coat.
—Thomas Nashe, "Prodigal Sons," 1588 [41]

By the eighteenth century, there was no biblical legend more firmly entrenched in high and low culture than that of the prodigal son. The academic tradition persisted throughout the century in paintings

and such reproductive prints as the *Return of the Prodigal Son* by Honoré Louis Gautier d'Agoty after Guercino, a color mezzotint of about 1770–75 (No. 10).[42] Academic painters rarely treated the theme in serial imagery, with the exception of Nicolas-Antoine Taunay whose unusual classicizing narrative, *L'Enfant prodigue,* was reproduced in a set of color intaglio prints, dating about 1795–1805, by Charles-Melchior Descourtis (No. 11).[43] It was in the picture-story format, however, that there appeared in England unprecedented numbers of inexpensive prodigal prints during the years between 1750 and 1800. The narrative served as a popularizing vehicle largely because it affirmed familial ideals. While there was no cessation of religious interpretations, these serials exploited the parable primarily as a lesson in conserving property, in right conduct, and in the perils of leaving home.

William Hogarth's moral fables from contemporary life, based on an adolescent's false aspirations to wealth and social position, situated the picture story in the mainstream of eighteenth-century print production. Sermons and plays on the prodigal theme, as well as European and English serial prints, provided ample precedent for Hogarth's *Harlot's Progress,* 1732, and *Rake's Progress,* 1735 (No. 12).[44] Hogarth conceived the first half of the *Rake's Progress* as an ironic variant on the prodigal narrative. The rake, an orphan, comes into his inheritance in the first scene (No. 12a), thus setting the stage for his extravagant expenditures, his orgy in the brothel (No. 12b), and—lacking parental example—his subsequent downfall. In two sets of plagiaries after Hogarth's prints, several unknown engravers, working from verbal descriptions of the original, incorporated a pair of prodigal son prints hanging on the wall in the background of the first scene (Fig. 2).[45] The prints within the print are inscribed *The Prodigal Son going from his carefull father* and *The Prodigal Son wasting his substance on harlots.* Whether Hogarth initially included these images in the rake's inheritance scene cannot be substantiated.[46]

But for the plagiarists and their audiences, resonances existed—as they had for centuries—between the prodigal's narrative and the rake's. There was no prototype, however, for Hogarth's methods of linking series of images like staged tableaux, with the protagonists enlarged in scale and the subsidiary characters drawn from real and imagined people. Never before this time had the storytelling capacity of printed images been explored with such robustness of characterization.

Hogarth's *Rake*, which circulated throughout Europe, may have inspired Voltaire's comedy in modern dress, *L'Enfant prodigue*, first performed in Paris in 1737. Certainly Sébastien Le Clerc II was familiar with Hogarth's prints when he produced the six scenes for his now-lost drawings or paintings, *L'Histoire de l'enfant prodigue*, ca. 1750. Le Clerc's set was reproduced by five printmakers and published in Paris in 1751 by Nicolas de Larmessin (Fig. 3), who advertised it as "a very instructive history which should be put before the eyes of young people."[47] De Larmessin's publication treats the scenes like a Hogarthian progress in recreating credible characters and settings from high and low life. Enormously influential, the French set of engravings was the source of at least twenty copies and variants during the next five decades in England, and its survivals persisted until the mid-nineteenth century in America (Nos. 21 and 22). Among the earliest of the outright copies was Richard Purcell's set of six mezzotints of about 1752-55 (No. 13). The variants that followed for 100 years maintained de Larmessin's titles and scenarios for their four or six scenes, but they often introduced alterations in poses (the pentient prodigal may sit under a tree) and always brought costumes, attributes, and settings up to date.[48] These printed narratives became defining instruments of moral and social respectability. Based on the Christian model, they purveyed a primer of the rights and wrongs of behavior for male adolescents. As shown in de Larmessin's set, in the first three scenes the prodigal's body expresses in sequence sinuous affectation, instability of

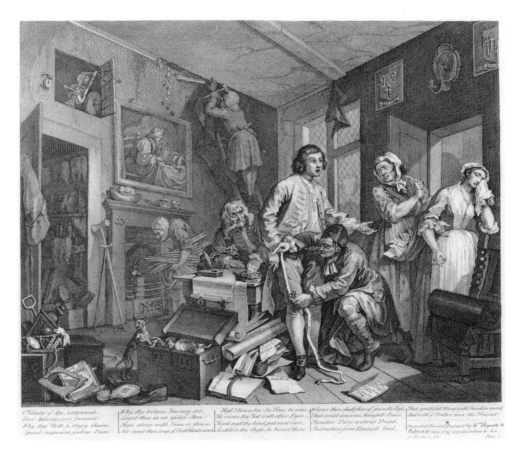

12 a. Hogarth, *A Rake's Progress*, Plate 1, 1735, etching and engraving

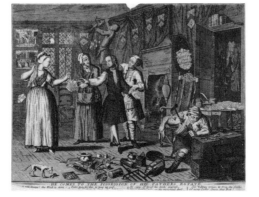

Fig. 2. Anonymous, *A Rake's Progress*, Plate 1, 1735, plagiary after Hogarth, engraving, Trustees of the British Museum (not in exhibition)

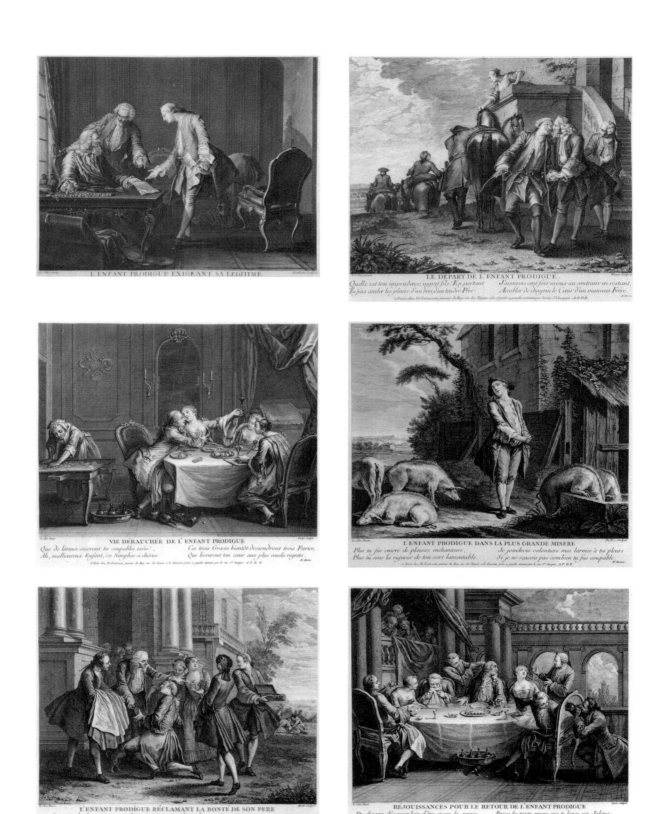

Fig. 3. *L'Histoire de l'enfant prodigue,* 1751, after Sébastien Le Clerc II, set of 6 engravings and etchings, published by Nicolas de Larmessin, Trustees of the British Museum (not in exhibition; see No. 13)

footing, and carnal abandon. Standing in penitence, his feet assume the proper right angles described in etiquette treatises. Kneeling and feasting with decorum, the prodigal in the final scenes rejoins polite society as an exemplar of restraint. This dance of postures served as a choreography of vice and virtue for the edification of youth.

The great increase in the number of London printsellers after the 1750s accounts for the widespread distribution of these popular narratives. Publishers such as Robert Sayer and Carington Bowles maintained prodigal sets among their large stocks of prints in varying sizes and prices, with or without hand coloring; they frequently bought up plates from other dealers and reissued sets many years after their first publication. Prodigal sets were advertised together with other series, such as the four seasons, rural and urban occupations, amusements, and manners and customs of the four parts of the world.[49] Public demand for printed pictures was spurred by increasing literacy and improved economic conditions during a period of relative peace. At one shilling or less for a set, even urban working-class families could afford to hang prodigal son prints on their walls. This is indicated by a passage from Charles Lloyd's 1798 novel *Edmund Oliver*, in which the hero's friend searches for him in London:

The landlady led the way up a narrow and dark pair of stairs, to a filthy and half-furnished bed room. The hangings were of a dirty check—the floor, which a worn-out rug at the foot of the bed scarcely concealed, was worm-eaten and rotten. The walls had been white-washed, but the plaister was now peeling off in several places. A large timber chest, and a few disfigured pictures, representing the parable of the Prodigal Son, were the only furniture, except the bed.[50]

Indicating a similar usage of prodigal prints is the set that found its way to a village in rural Russia to play a central role in Pushkin's *The Stationmaster*, written in 1830. The narrator of the story describes each of the four scenes in detail as he saw them hanging in the stationmaster's house. He notes that these quaint relics from the past were inscribed with German verses and that the prodigal son wears a tricorn hat.[51] No doubt the set was one of the eighteenth-century German publications that, like the English versions, reproduced de Larmessin's prints after Le Clerc.

For eighteenth-century popular culture, the prodigal narrative was central largely because of its powerful appeal to family concerns. Affection and mutual respect had become important ideals for happy domestic life, resulting in a remarkable shift in attitudes away from the father-centered family to the child-centered, a movement that reached its peak in the 1770s.[52] John Locke's *Some Thoughts Concerning Education*, 1693, reprinted nineteen times before 1761, was of critical importance in stressing the need for more egalitarian family relationships.[53] Locke rejected the notion of original sin and urged parents to understand the child's development as a gradual process, not encouraged so well by the rod as by conditioning and parental example: "He that would have his son have a respect for him and his orders, must himself have a great reverence for his son."[54] Among the great number of texts on the subject of parental authoritarianism, Samuel Richardson's *Clarissa*, 1749, exemplified the fatal consequences of a father's tyranny. Rousseau's theories of "natural inclination" and a vast body of pedagogical literature encouraged parents to restructure the family on a more democratic basis. The greater autonomy granted to each member of the household, as a consequence, caused families to become more closely knit, bound by the ties of affection.

The new ideology found strong support among the mercantile class and landed squirearchy. Many of these families believed in noncoercive childraising and, because they also feared the erosion of filial deference and respect, their traditional values were embodied in the prodigal narrative. It taught a lesson in scripture and a code of social and ethical conduct. As the pictures make clear, it promoted the notion of the family unit as a haven from a threatening, disorderly world. The powerful attraction of a loving household served a significant function in a time of increasing social, occupational, and geographic mobility, when family bonds were strained.[55] Sons on the Grand Tour were subject to worldly lures. More important, at a time of great mercantile and territorial expansionism, sons who left home for economic reasons—especially younger sons—were prey to many temptations in urban centers or the far-flung colonies.

Laurence Sterne, influenced by Locke's theories, commented on the ambiguities of these family concerns in his "Prodigal Son," published in *The Sermons of Mr. Yorick*, 1766. Throughout his sermon, Sterne stresses the "fatal passion" that impels the prodigal to break away from home. The desire to travel is inevitable; to vegetate in the parish dulls the inquiring mind:

Man surely is a compound of riddles and contradictions: by the law of his nature he avoids pain, and yet *unless he suffers in the flesh, he will not cease from sin* The love of variety, or curiosity of seeing new things. . . seems wove into the frame of every son and daughter of Adam . . . It is to this spur which is ever in our sides, that we owe the impatience of this desire for travelling: the passion is in no way bad. . . order it rightly, the advantages are worth the pursuit.[56]

Sterne's sermon, in turn sentimental and paradoxical, addresses tensions inherent in parents' moral commitment to their children's independence, and the pain of the lessons of experience. These were the active issues—how to guide the child toward self-sufficient maturity and yet to beckon the child homeward—raised by the parable and underlying the popularity of its picture stories.

Chameleon-like, the prodigal son parable in late eighteenth-century England assumed the comic mode as caricaturists sent up its moral message to lampoon two members of Britain's most renowned dysfunctional family: the Prince of Wales and his father, George III. The Prince had been widely satirized for his scandalous behavior with women, his gluttony, drinking, and gambling. That he was also estranged from his father added to his credentials for portrayal as a real-life prodigal

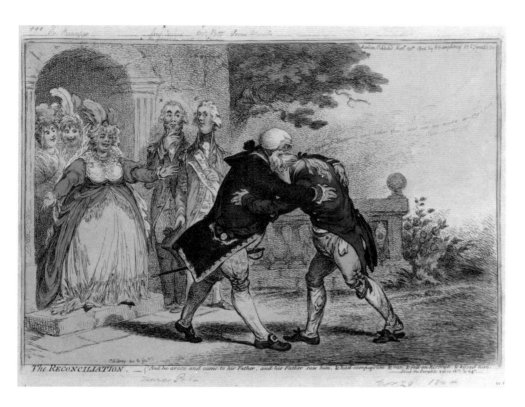

17. Gillray, *The Reconciliation,* 1804, etching with hand coloring

son, an especially apt characterization at a time when the King's illness in 1785 precipitated fears about the succession. Trading on popular recognition of the subject, familiar from the many prodigal son sets on the market, Thomas Rowlandson and James Gillray, among others, embellished their caricatures of the Prince with inscriptions from the biblical text or with postures appropriate to the scenes of debauchery, penitence among swine, and reconciliation (Nos. 16 and 17).[57] Their satires expressed strong indictments of a family relationship in which the father was seen as no fit parental model and the son as a wastrel, incapable of remorse for his errant way of life. By treating the royals as buffoon exemplars of father and prodigal son, caricaturists undermined commonly-held expectations that the parable serve the ideals of modern family life.

The parable of the prodigal son in France and England in the later eighteenth century found a new language when transformed into the *drame bourgeois*. One of the popularizers of this form of moral genre was Jean-Baptiste Greuze, who alluded to the prodigal theme in his *The Father's Curse* and *The Punished Son*. When exhibited at the Salon in 1765, the drawings occasioned "extreme emotion" in one viewer, who suffered "too much at the sight of them."[58] Greuze's large canvases of the two subjects, exhibited in 1777 and 1778, were praised as history paintings evoking "tears of compassion."[59] Greuze's pitiable scenarios, punctuated by declamatory gestures of cursing and lamentation, told the dark side of the story of a prodigal son who exiled himself from his family and returned too late for paternal redemption. Shortly after Greuze's exhibition, the Académie Royale in 1782 chose the parable as the required subject for the Prix de Rome competition.[60] Typically, these compositions represented the narrative in what was considered to be archaeologically appropriate classical dress and settings, similar to the series by Descourtis after Taunay (No. 11). Archaizing trappings notwithstanding, these elevated subjects in neoclassical art expressed the same middle-class family values as those found in Greuze's moralizing *tableaux vivants*.[61]

Greuzian *sensibilité* and the Le Clerc model in combination were the companionate sources for two highly imaginative series by the English artist John Raphael Smith: *History of the Prodigal Son*, 1775 (No. 14) and *Laetitia*, 1789 (Fig. 4 and No. 19). Smith's *Prodigal Son*, intended for consumers willing to pay twelve shillings for uncolored sets or eighteen shillings for colored, was advertised with the same description by his publisher in both 1784 and 1795 as a "much admired set" that "should be received into every family as a suitable memento constantly at hand, to remind the young and inexperienced to shun the paths of vice and misery, and to pursue the steps of virtue and happiness."[62]

14 a–e. Smith, *History of the Prodigal Son*, 1775, set of 6
mezzotints with hand coloring (plate 2, courtesy
The Library Company of Philadelphia; not in exhibition)

The PRODIGAL SON Receives his PATRIMONY

The PRODIGAL SON TAKING LEAVE

The PRODIGAL SON IN EXCESS

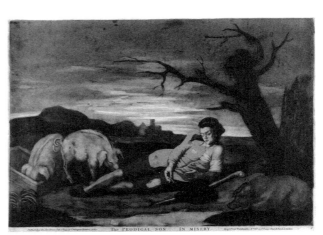

The PRODIGAL SON IN MISERY

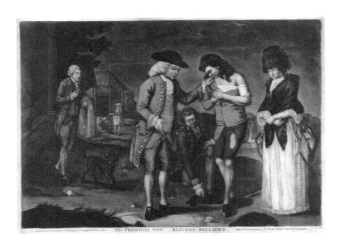

The PRODIGAL SON RETURNS RECLAIM'D

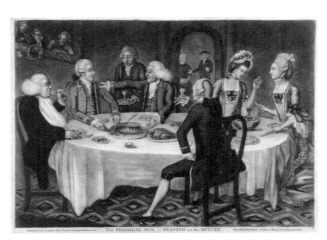

The PRODIGAL SON FEASTED on his RETURN

Fig. 4. Smith, *Laetitia*, 1789, after George Morland, set of 6 stipple engravings, Trustees of the British Museum (not in exhibition; see No. 19)

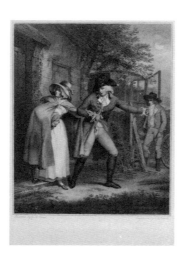

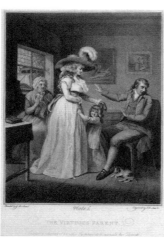

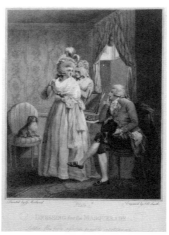

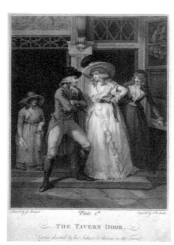

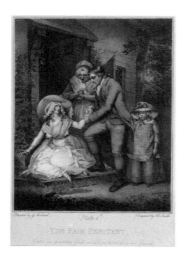

That Smith's 1775 series retained its hold on English audiences for more than twenty years after its first issue was due, in part, to its representation of the prodigal as a man of feeling. Neither kneeling nor standing nor sitting, Smith's prodigal among swine—one shoulder bared and hair loose—signals his repentance by lying down on the ground and weeping. A large tear is visible on his cheek. Upon his return, the prodigal stands upright, slightly taller than his father. Although several printmakers followed Smith's lead in presenting the prodigal standing (No. 15d), there was neither significant precedent nor sequel for his recumbent figure.[63] His posture and tears recall no other masculine figure in the history of art; rather these feminine attributes draw upon familiar associations with the recumbent woman in the wilderness, Mary Magdalen. Widely interpreted as a sinner forgiven by Christ, the Magdalen was seen as the prodigal son's biblical counterpart in literature and art.[64] Her reclining representation by Antonio Correggio, ca. 1522 (destroyed, formerly Dresden, Gemäldegalerie), similar to that of Smith's prodigal, was one of the most widely reproduced images of erotic religiosity and pathos in eighteenth-century engravings.[65]

Referring to the Magdalen theme in his series *Laetitia*, 1789, after George Morland (Fig. 4), Smith conflated the prodigal's and sinning woman's narratives to invent the story of a prodigal daughter. With the initial two scenes of a country innocent seduced and living in London with a rich man, Smith follows the well-worn plot of Hogarth's *Harlot's Progress* which, throughout the century and into the next, prepared the audience for the woman's inevitable downfall. The story shifts to a key episode represented in the third plate, in which Laetitia goes home, an unregenerate kept woman, to offer money to her father. He rebuffs her, underscoring with his outstretched arm a print of the Magdalen in a *Noli Me Tangere* hanging on the wall beyond. Abandoned by her lover, reduced to soliciting on the streets, Laetitia returns home once again, this time a penitent, to find forgiveness

from her father. It can scarcely be an exaggeration to state that, among the vast numbers of images produced in the Hogarthian retributive mode, Laetitia's story marked a radical revisionism of the standard images and texts in which, once fallen, the woman becomes an unredeemable outcast.[66] For the first time in the history of Western secular imagery, a whore—a street whore at that—is forgiven for her past and taken back into the family fold.

Laetitia was so popular that the worn plates were later restored and republished, and numerous copies appeared in the English and European trade. Typical of these is the set of stipple engravings in reverse by an unknown printmaker who signed his name "Bartoloti" or "Bartolotti" to capitalize on the market value of prints by Francesco Bartolozzi (No. 19).[67] Why a narrative of a sinning woman, granted the same parental forgiveness as a prodigal son, should meet popular acclaim in 1789 and for several decades beyond, may be explained by her association with the Magdalenism movement in British philanthropy of the period. Visual support for this is present in the only other known prodigal daughter image of the period, George Quinton's *Magdalen Hospital for the Reception of Penitent Prostitutes,* ca. 1789–90, after Thomas Spence Duché (No. 20a). In 1797, Quinton's Norwich patron, W. Stevenson, wrote a letter to a London newspaper praising Quinton's print and describing the figures as "Charity, presenting an emaciated prostitute, in a state of despair, to three reclaimed females at the door of the Magdalen hospital."[68] Quinton's kneeling prostitute, her hair in wild disarray, appeals to a woman in neoclassical dress, a stand-in for the prodigal's compassionate father. Three inmates in hospital uniform, analogous to the biblical servants, hold the new clothes that will replace the old. Quinton's print promoted the goals of the hospital, which had been founded in 1758 by a group of philanthropists sympathetic to the plight of women forced to become prostitutes. The hospital's inmates were the subjects

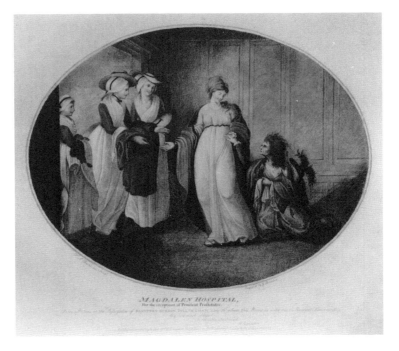

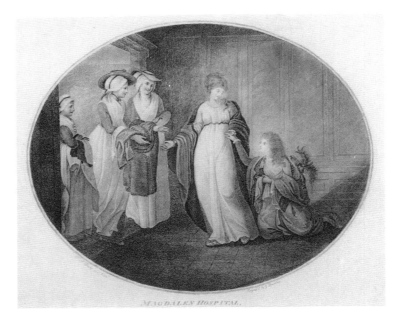

20 a–b. Quinton, *Magdalen Hospital for the Reception of Penitent Prostitutes,* 1797, after Duché, stipple engraving (top) first state; (bottom) second state

17

of numerous so-called "true" case histories that, together with sermons delivered in the hospital's chapel, often associated the prostitute's story—"she was dead and is alive again"—with the narrative of the prodigal son.[69]

But apparently Quinton's prostitute was too disturbing for later audiences to accept. At an unknown date, the publisher had the plate reworked to alter her expression into a generalized depiction of pathos, and her unkempt hair into tidy curls (No. 20b). Here is an abject female whose past has associations less with the refuse of London's streets than with the seduced, or about-to-be seduced, women for whom the Magdalen Hospital also provided a haven. The more compliant version, vivid evidence of the discourse of sympathy for women as a way of regulating their behavior, represents a cultural shift in attitudes toward institutionalization. The public was deeply concerned that revolutionary ideas in France after the Terror of 1793 would spread to England's disenfranchised classes. Philanthropy and criminal justice, as a result, took on a harsher and more punitive tone at the end of the century. Wilberforce, Wesley, and the Evangelical movement had recently joined together to establish the Proclamation Society for the Encouragement of Piety and Virtue. With the Bowdlers' Society for the Suppression of Vice, "indecent prints" were attacked and brothels came under stricter licensure. Abuses crept back into prison administration and a new type of radial architecture was devised for incarcerating male and female offenders in what became known as penitentiaries.[70] An influential figure opposed to social reform, Hannah More, in 1799, criticized aid to the degraded prostitute as being soft on sin and thus only contributing to further vice: "Be not anxious to restore the forlorn penitent to that society against whose laws she has so grievously offended. . . . To restore a criminal to public society, is perhaps to tempt her to repeat her crime."[71] For the Magdalen Hospital to maintain donations and public support, it had to suppress the notion that it was a harbor for criminals. Quinton's prostitute, therefore, was

de-criminalized and de-sexualized, given a more acceptable past than that of the common whore, so overtly declared in the first state of the print.

Sinning women's narratives surfaced in the nineteenth century in France, where the tradition of prodigal son series, as Linda Nochlin has pointed out, "emerged as the *topos* of the *fille coupable*—the guilty daughter—in a wide range of variations."[72] The presiding theme of these prints stressed the adulterous woman's return to the family as an "acceptance of the country girl's 'natural' humble position in society."[73] In the Victorian era and beyond, however, no such solution could retrieve the soiled past of a prostitute like Laetitia, for whom the parable's message did not apply.

Nineteenth-century prodigals in modern life

Prodigal son narratives in contemporary dress disappeared in England and on the Continent until the tradition was reinvestigated in an innovative series of 1881.[74] But from about 1796 until the mid-nineteenth century, American printmakers continued to borrow the titles, sequencing of scenes, and use of poses and gestures from earlier English series.[75] The most influential of the sets, Amos Doolittle's *Prodigal Son*, published in 1814 in Cheshire, Connecticut (No. 21), replicated four mezzotints published in London in 1799.[76] Not troubling to change any detail of the English prototype, Doolittle faithfully copied the characters, costumes, and settings, including the books and paintings in the father's house and furnishings in the brothel, as well as the swinery and father's garden landscape with its Georgian house in the background. At least two printmakers reproduced Doolittle's etchings: in sets of lithographs published by D. W. Kellogg in Hartford, Connecticut, in 1832/33-40, and by Albert Alden in Barre, Massachusetts, about 1850.[77] Neither these sets nor the updated prodigal lithographs published in New York at some time between 1838 and 1852 by Nathaniel Currier (No. 22) departed from the narrative convention originating with de Larmessin's 1751 set

after Le Clerc. The Currier firm and its successor in 1852, Currier & Ives—whose combined production until 1907 amounted to 7,500 titles—issued no other such sets or, for that matter, any single-sheet images of the prodigal son.[78]

In an age of rapid expansion and mass migration to the cities, social institutions of patriarchal family, community, and church—where the prevailing pattern was authority and deference—were undergoing profound transformations. Loosening ties between family generations, as Karen Halttunen has pointed out, undermined "the traditional paternal task of teaching sons how to make a living, and the family's role as educational institution."[79] After 1815, an outpouring of advice manuals, aimed at adolescents as young as fourteen, addressed fears about boys moving to industrial centers and their moral contamination by predatory sharpsters, gamblers, and prostitutes.[80] With greater immediacy than prodigal sets after the English stereotype, wood engravings spelled out for young men the lethal consequences of urban vice.[81] Later images, novels, dramas, and conduct books, aimed at those in social motion, became increasingly success-oriented. Although the many leave-taking scenes of this period appear to resonate with the prodigal narrative, the country boy's decision to seek status and riches in the metropolis marked him as an entrepreneur within the prevailing cult of the self-made man.[82] Even by the time of Doolittle's series, however, prodigal prints on American walls expressed old-fashioned family values under threat. In their appeal to a lingering mythology in popular culture, they represented a nostalgic looking backward to a less complex society, a more innocent age.

While the popular narratives lost their market, there was no corresponding decline of interest in the prodigal theme among academic artists. In France in the 1820s and 1830s, the prodigal son in the medievalizing "troubadour style" in paintings, drama, and literature was common subject matter among romantic artists of the Bourbon era.[83] By mid-century, this type of conservative historicism, harking

21 a–d. Doolittle, *The Prodigal Son*, 1814,
set of 4 etchings and stipple engravings with
hand coloring

The PRODIGAL SON receiving his PATRIMONY

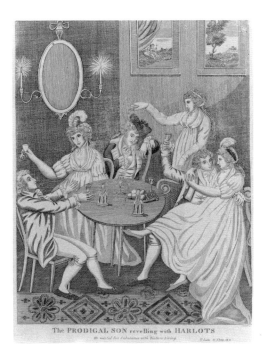

The PRODIGAL SON revelling with HARLOTS

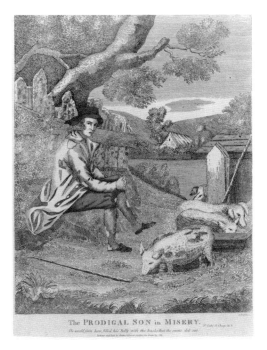

The PRODIGAL SON in MISERY.

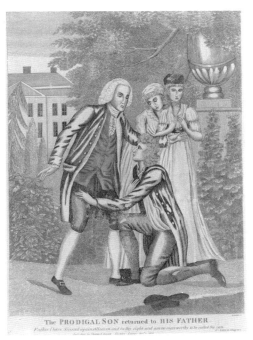

The PRODIGAL SON returned to HIS FATHER

back to an old order, was no longer relevant. More typical of the prodigal's treatment in history paintings and fine prints was the narrative's reconstruction within its Middle-Eastern context. Edward John Poynter's *Return of the Prodigal Son*, 1869 (New York and London, Forbes Magazine Collection), was criticized for its archaeologizing exactness as to the "precise shape, measurement, pattern, and material, if not also the market price of the textile fabrics" worn by the prodigal's father.[84] But Poynter's wealth of description was acceptable to those who saw in scriptural illustration a means of evoking the mystery and exoticism of the Holy Land. The convention of representing the prodigal in quasi-biblical dress or near-nudity persisted, as shown in prints by William Strang, 1882 (No. 24) and Alphonse Legros, about 1870-90 (No. 25), and even in a platinum print of 1909 by pictorialist photographer F. Holland Day.[85]

Orientalism was a primary text for academic artists depicting prodigals in the second half of the century; therefore James Jacques Joseph Tissot miscalculated public response when he produced two medievalizing paintings of the subject: *Retour de l'enfant prodigue,* 1862 (New York, Manney Collection), and *Le départ de l'enfant prodigue à Venise,* 1863 (location unknown).[86] These stagy productions in the *genre troubadour*, with their Flemish and Venetian costumes and settings, invited criticism when they were exhibited as pendants at the 1863 Paris Salon.[87] In London, where Tissot exhibited his *Retour* at the Society of British Artists in 1864, F. G. Stephens described the painting as "affected, false, and artificial. . . . [it] is strange that a man who is so powerful an observer of character should condescend to so *bizarre* a school of painters as that of ancient Flanders."[88] Thereafter, Tissot abandoned religious themes for more than fifteen years, continuing to concentrate on contemporary subjects after he moved to London in 1871.

Ten years later, Tissot returned to the parable, this time taking the unusual step of representing it in a set of four paintings:

The Prodigal Son in Modern Life, 1881 (Nantes, Musée des Beaux-Arts). These he exhibited in 1882 at the Dudley Gallery in London, together with their replicas in watercolors and prints (No. 23).[89] By affiliating the etchings with their exhibition-piece originals and executing them in virtuosic techniques in the tradition of Rembrandt, Tissot elevated his set to the status of a collectible in the fine-print market. He thereby dissociated it from the vernacular idiom that had prevailed in prodigal narratives since the late seventeenth century.

At the same time, Tissot retrieved the Hogarthian mode by weaving into his narrative credible characterizations and settings. The departure scene takes place in the father's Thames-side office where, fashionably dressed and fleshy of chin, the prodigal sits on a table facing his father. His back is turned to the older brother, who gazes out the window, and to a young woman, presumably a sister, who sews.[90] In the following scene, the prodigal "in foreign climes" has traveled to Japan where, seated in a waterside pavilion floored with mats and hung with lanterns, he watches dancing courtesans. Tissot, influenced by Whistler, was himself an enthusiastic *Japoniste*. The Rembrandt-influenced return, with the prodigal's toes turned under and his body wrapped in the father's arms, occurs in a shed beside a ship being off-loaded with swine and cattle. The last scene, the feast, takes place at a stream-side gazebo. Watery settings unify the narrative's construction: in the first and third scenes, maritime references underscore the family's source of wealth and the consequences of its waste; in the second and fourth, waterside places of leisure contrast sexual fantasy abroad with domestic ritual at home.

Critical commentary was affirmative, if tepid, although no one remarked that Tissot took far greater license with the parable's canonical representation than he had in his earlier prodigal paintings. Breaking with all past conventions, Tissot conflated in the third scene the two key episodes of penitence among swine and the return—heretofore always distinctly

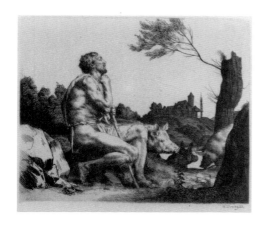

24. Strang, *The Penitence of the Prodigal Son*, 1882, etching

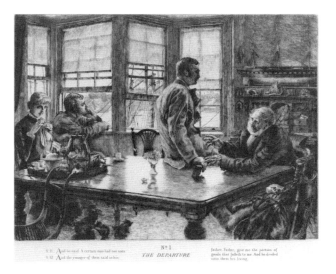

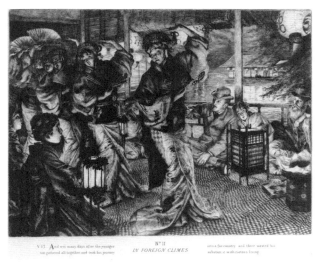

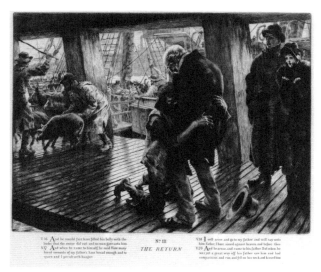

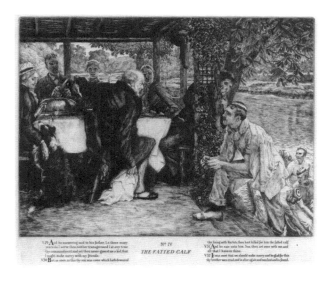

23 a–e. Tissot, *The Prodigal Son*, 1881, set of 5 etch-
ings and drypoints

separate in time and place. By taking license with the parable's account, Tissot was able to conclude it with a fourth episode that earlier artists had almost entirely ignored: the older brother's assumption of his biblical speaking role.[91] Interrupting the banquet, the older brother has come up the steps from a boat in which are four of his friends, all wearing caps identifying them as members of a sporting club. Hands clenched on raised knee, the older son looks intently at the father. The latter points across the table to the prodigal son, in shadow on the left, and tells the older son to be glad that his brother, once lost, is found. The prodigal prepares to carve the fatted calf, here a roast beef still under its silver cover. He tilts back, observing the central dialogue with hooded eyes and faint smile, projecting a mixture of smug self-satisfaction and hostility as he wields a curiously prominent and gleaming knife. The older brother, inappropriately clothed for the event, displaced from the family circle, and in a semi-suppliant posture, is a figure at odds with the group.

The tension generated across the composition underscores ambiguities in the parable's exposition of the relationship between father and sons. Audiences commonly understood that the older brother symbolized the judgmental people who criticized Christ's willingness to forgive sinners. Rarely had artists given him a primary place in images of the return; more usually he stands apart among witnesses, as in Testa's fourth scene (No. 9d). In Rembrandt's late painting of the return, the towering figure of the older brother is the symbolic expression of righteousness, shadowed metaphorically by conflict over the father's act of forgiveness.[92] Audiences were expected to sympathize with the penitent sinner rather than with the upright son who had never transgressed. But just how morally redeemed is Tissot's passive-aggressive prodigal son? What, Tissot seems to ask, has he learned about the biblical lesson of charity toward others? Who can help but share in the sense that the older brother has reason for resentment? In short, Tissot demythologizes the brothers' symbolic duality by giving equal weight to their rivalry within the universal, and very human, contest for a father's approval.

Tissot's preoccupation with the parable, and especially his hitherto-overlooked twist on its meaning in 1881, again raises the issue of the prodigal narrative as autobiography. He had been brought up in a devout Catholic family, but gave no indication at mid-career whether he was a lapsed or practicing member of the faith.[93] That Tissot was self-exiled from his native land resonated with the parable. Since he was to return to France in November 1882, immediately after the lingering death from tuberculosis of his common-law wife Kathleen Newton, Tissot may have held in his mind the unspoken possibility of a return when he produced the series a year earlier. His father, then still alive, was an avid conchologist; thus there is a self-referential marker in the seashell on a shelf in the father's office in the first scene. Finally, as the second of four sons, Tissot was no stranger to fraternal strivings. But these associations between artist and subject remain inconclusive. What is irrefutable was the pride he took in the *Prodigal Son in Modern Life*. He displayed the paintings and prints at the Palais de l'Industrie in 1883, his first one-man exhibition after his return to Paris. The painted set, with the exception of one portrait, was his only submission for exhibition in the 1889 Exposition Universelle in Paris, where he was awarded a gold medal. In the 1893 World's Columbian Exposition in Chicago, Tissot exhibited a portrait and—as his sole other contributions—the prodigal son prints and the paintings, which he was to bequeath to the Musée Luxembourg.[94]

In several subsequent prodigal images, however, Tissot forged a fervent alliance between his renewed Catholicism and treatment of subject matter. Having experienced a religious vision in 1885, Tissot traveled in Egypt and Palestine, where he made life studies for the most ambitious project of his late career: 365 gospel illustrations in watercolor and gouache for *The Life of Our Saviour Jesus Christ*.

When many of these were exhibited in Paris in 1894, visitors were said to have kneeled and prayed before the images.[95] Among the illustrations were two versions of the parable: *The Prodigal Son*, from a photograph of a Palestinian youth guarding swine, and *Return of the Prodigal Son*. In the latter image, Tissot replicated the poses and gestures of father and son in his 1881 dockside return scene, but placed them in a Casbah-like setting and substituted for Victorian costume the appurtenances of Orientalized dress.[96]

For Catholics, Tissot's pictorial and religious conservatism validated Christian ideology, reflecting an orthodoxy that was especially appropriate at the turn of the century. Catholicism at that time in France, as Ian Thomson has pointed out, was a "live political issue," actively undertaking a renewed mission to oppose anticlerical or atheistic beliefs held by, among others, adherents of Darwinian theory, Marxism, and Republicanism.[97] Tissot's approach to the works at the end of his career sited his religious subjects within the theological fold as restatements of "the mystical superiority of the Catholic vision."[98] In contrast, his *Prodigal Son in Modern Life* explored those failures of understanding that were to be a primary concern of twentieth-century authors of exile narratives. With his prodigal etchings, however, Tissot concluded a narrative tradition that had been the province of printmakers for four hundred years.

Redemption and exile in the twentieth century

After Tissot's late work came Jean-Louis Forain's intensely spiritual expression of the parable's message. Forain had been profoundly influenced by the conversion to Catholicism of his close friend and supporter, J.-K. Huysmans, and in 1900 had written Huysmans about his own new-found religiosity and his decision to turn to biblical themes.[99] The earliest of his religious subjects appeared nine years later: in an oil painting, *Retour de l'enfant prodigue*, 1909 (Boston Public Library) and five single-sheet etchings of the same theme.

With these images, Forain's biographer believes, "Forain may have characterized his own return to the church after a period of bohemian living."[100] The painting's closest counterpart among the etchings, *Return of the Prodigal Son* (No. 26), indicates that Forain had looked closely at Tissot's dockside return scene of 1881. Wearing a heavy overcoat, the father stands with legs apart, knees slightly bent, clasping the kneeling son to his breast. Forain, however, avoids Tissot's particulars of description by massing the two figures into a flattened, compacted shape. The prodigal's body is almost obliterated as he sinks into the blackened bulk of the father's coat. Forain similarly exaggerated the father's scale in his other etchings of the return narrative to stress the patriarch's symbolic authority over the abject sinner. Forain was to return to the prodigal narrative in 1912 and 1913 with three etchings of the departure scene that again suggest autobiographical associations between the parable's theme and the artist, whose son had left for army service and whose own house appears in the background.[101]

Forain's preoccupation with the parable had a pressing agenda when he addressed the return theme repeatedly in 1909 as the first of his biblical subjects. For Forain and orthodox Catholic audiences as well, a renewed emphasis on the prodigal's submission served as a timely rebuttal to a scandalous interpretation of the narrative by a Protestant author: André Gide's own version of the parable, *Le Retour de l'enfant prodigue,* 1907. In Gide's fable, the prodigal is the middle of three sons. Having experienced in his travels both ecstasy and disenchantment, the prodigal returns home. Only after the prodigal engages in dialogues with his father, older brother, and mother does the reader discover the reason why he chose to renounce his freedom. By assuming family duties, he has made possible the liberation of the younger brother who yearns for the experiences of life. At the end, the prodigal goes to the boy's bedside and reassures him: "Come! Kiss me, my young brother: you are taking with you all my hopes. Be strong; forget us; forget me. May you never return. . . ."[102]

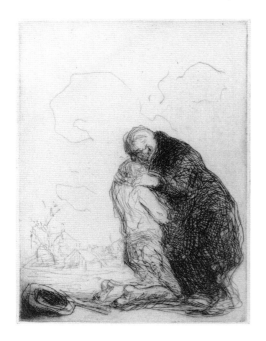

26. Forain, *Return of the Prodigal Son,* 1909, etching

Escape from stifling rules, whether of family, Church, or any higher authority, was a guiding theme in Gide's writings. He expressed himself on the subject as adversary throughout his thirty-year correspondence with Paul Claudel, who never abandoned his mission to convert Gide to Catholicism.[103] "They took me for a rebel," Gide was to write in his journal in 1914, "because I was unwilling to . . . force myself to that cowardly submission which would have assured my comfort. That is perhaps the most Protestant trait I have in me: my horror of comfort."[104] Challenging orthodoxy in his life and writings, Gide saw himself as both puritan and libertine, moralist and sexual nonconformist, attempting to reconcile conflicts between the search for identity and the rules imposed by religion and society.[105]

Weaving throughout the twentieth century in literature and art are conflicting interpretations of the narrative, such as those represented by Forain and Gide. Rainer Maria Rilke had read Gide's *Retour* three years before he finished his novel *The Notebooks of Malte Laurids Brigge* in 1910. Finding in the parable potent metaphors for estrangement in the prodigal's self-imposed exile and return, Rilke appended his own revision of the narrative at the end of the novel.[106] Rilke's prodigal, stifled by the family's possessiveness, finds on his journeys that he must reject externally imposed moral laws and the love of all humans in order to know himself. Upon his return, he begs his parents not to love him; they misunderstand and grant forgiveness. The prodigal realizes that their love has nothing to do with him. "He almost had to smile at their exertions, and it became clear how little they could have him in mind. What did they know of him? He was now terribly difficult to love, and he felt that One alone was able for the task, but He was not yet willing."[107] Rilke had earlier addressed the theme in his *The Departure of the Prodigal Son,* 1906, a poem expressing the futility of abandoning the known for an "obscure hope. . . to die alone and destitute not knowing why."[108] Shortly before and after he wrote the poem cycles

of 1906, Rilke traveled on two occasions to the Elisabethkirche in Marburg to see its renowned fifteenth-century prodigal son tapestry, the "schönen Wandteppich."[109] This post-medieval narrative in eight episodes vivified a central theme in Rilke's work: "we live our lives for ever taking leave."[110] Certainly, the tapestry's concluding episodes of the return and family feast offered comforts of redemptive love that the author himself almost never found.

In Franz Kafka's *Heimkehr*, 1922–23, a fragment referring to the prodigal's return, a man stands in the family's farmyard asking himself who will be there to receive him. The longer he hesitates, the more estranged he becomes, for whatever is going on in the house "is the secret of those sitting there, a secret they are keeping from me." Like the rootless stranger in a wealth of twentieth-century exile narratives, the prodigal asks himself: "What would happen if someone were to open the door now and ask me a question? Would not I myself then behave like one who wants to keep his secret?"[111] The prodigal, like the father, cannot yield up his own identity—his secret—for a resolution of the existential dilemma. He is the modern alienated prodigal son for whom there is no higher authority to grant absolution.

These literary reinterpretations in the first decades of the century correspond with few representations of the parable in the visual arts. With a lack of interest in religious subjects in general and diminishing patronage from the Church and lay Christian audiences, illustrations of the prodigal narrative declined abruptly. For those artists who did draw on the theme, almost all of them retained the conventions of representing the story in biblical or modern dress, glossed with the standard kneeling postures of penitence and submission. Unsurprisingly, artists incorporated into their interpretations elements of modernist styles: Cubism (Constantin Brancusi's oak carving, 1914–15); Expressionism (the biblically-costumed return scenes in Max Slevogt's lithograph, 1912, and Christian Rohlfs' woodcut,

ca. 1916); Surrealism (Giorgio de Chirico's drawings and paintings from 1917–24, and his lithographed return scene of 1929); Futurism (Sybil Andrews' color linocut of an Orientalized return, 1939); and various expressions in more literal transcriptions of the father and son's reunion (Julius Komjati's etching of about 1920-25 and Albert Edward Sterner's etching, 1930).[112]

While these earnest treatments of the salvation theme retained the parable's Christian message, less heedful of biblical accuracy were the jazz-age brothel prints of Jules Pascin. In five intaglio prints executed between 1924 and 1927, as exemplified in his drypoint *L'enfant prodigue chez les filles*, 1926 (No. 27), Pascin characterized the prodigal as a rustic with a swineherd's staff. Rather than expressing penitence in the fields, he has arrived at—or returned to—a brothel where, enthralled, he stares at swarms of prostitutes in abandoned postures.[113] Pascin's interpretations are buoyantly hedonistic recollections of merry company scenes and Hogarth's Rake at the orgy.

A redemptionist interpretation of the parable, which also included flamboyant seduction episodes, appeared in 1929 on the Paris stage. This was Serge de Diaghilev's production of the ballet *Le fils prodigue*, with music by Serge Prokofiev and choreography by Georges Balanchine. Georges Rouault produced the ballet's Orientalist costumes and set designs.[114] Serge Lifar danced the role of prodigal son, partnered by Dubrovska as the siren. In Balanchine's emotional climax, the prodigal crawls on his stomach across the stage to the father who enfolds him in his cloak.[115] Lifar later wrote in a memoir on the life of Diaghilev that, at first, he agonized about the role. Early one morning, unable to sleep, he suddenly remembered returning as a youth to Kiev: "to my father's threshold, from my first unsuccessful effort to fly abroad—I, a Prodigal Son, waiting for dawn." Identifying Diaghilev as a father figure whom he could not betray, Lifar leapt from bed to go to the theater: "I have created the Prodigal Son. It is myself."[116]

Contrasting with redemptionist treatments in twentieth-century imagery, dance, and music are the self-referential prodigals of two entirely disparate artists—Max Beckmann and Thomas Hart Benton—for whom the narrative served to convey unresolved angst. In about 1918, Beckmann produced a set of six gouaches and watercolors on parchment for his series *The Prodigal Son*.[117] The departure scene is lost, but Beckmann's drawings of the prodigal's dissipation in the brothel, penitence among swine, return, and feasting retain the tradition of illustrating the parable in modern dress within a narrative sequence that flows to its inevitable conclusion. Another of the drawings, however, representing a claustrophobic scene of the prodigal among thieves (Fig. 5), offers more biting commentary on human vice. Here, the prodigal's face dominating the center of the composition is a portrait of the artist himself.[118] With wall-eyed stare and hand cupping his chin, he is besieged by grotesque figures who encircle him with their hands—cupped, pointing, and gesturing—in a sign language of greed. Another hand is held up, as if in warning, by a Christ-like figure in the background. Beckmann's prodigal—like Hercules at the Crossroads or Everyman or Adam—is immobilized by inner conflict as he confronts the act of moral choice. A similar irresolution characterizes the protagonist in Beckmann's painting *The Prodigal Son*, 1949 (Hannover, Niedersächsische Landesgalerie), executed in the year before the artist's death while he lived in exile in the United States. Here the prodigal, seated among prostitutes holding his head in both hands, represents a non-individuated figure of despair. He has been seen as a surrogate self-portrait, embodying the artist's sense of loss of identity, described in the third person in a diary entry written in St. Louis that same year: "Beckmann at last moved to a far, big country, and slowly we saw his figure growing more indistinct. Finally it disappeared entirely in certain distances."[119]

Exile and autobiography are questions raised by one of the century's bleakest—

and most problematic—images of the parable's conclusion: Thomas Hart Benton's *The Prodigal Son*, a lithograph of 1939 (No. 28). Benton's middle-aged prodigal in city clothes has driven home in an old truck, put his suitcase on the ground, and in consternation—hand held to chin in a gesture reminiscent of Beckmann's 1918 prodigal (Fig. 5)—stares at an abandoned ruin in a desolate landscape. In the right foreground is a carcass instead of a fatted calf. Benton described the scene as representing "the belated return" of the prodigal, and the house as one based on a fallen-down structure familiar to him from the summer months he had spent since the mid-1920s in Massachusetts "at the foot of Boston hill in Chilmark, Martha's Vineyard."[120] The painting in reverse of the same composition, *The Prodigal Son*, ca. 1940–41 (Dallas Museum of Art) incorporates in the sky red-tinged clouds in the shape of running hounds that have been interpreted as metaphoric of the conflagrations of the second World War.[121] Benton's description of the return as "belated" suggests that, had the prodigal gone home sooner, he might have found the redemption to which he aspired. By the time of the painting, war called into question the parable's lesson that right choice leads to salvation.

Despite the Chilmark house used as model, Benton's scene is typical of the Depression-era Midwest, with its drought-stricken abandoned farms and ubiquitous cattle bones. Four years before he produced the lithograph, Benton had himself left New York to return to his native Missouri. He continued to pursue readily-understandable populist imagery, drawing directly on his own experience, to project the actions and environment of ordinary people. Raised in a Methodist-Baptist family, Benton used biblical references as a means to reach audiences for whom Scripture was the source of literal truth. Many of his contemporaries also found survivals of a frontier culture in popular fundamentalist sects that offered rich subjects for representation in literature and art: revival meetings, baptisms, and other spiritual experiences in daily life.[122]

Commentators, embroiled in the controversy over the vulgarity of Benton's *Susanna and the Elders*, 1938 (The Fine Arts Museums of San Francisco), took no note that Benton's *Prodigal Son* was even more disruptive of biblical legend. *Susanna* shocked audiences, with its rendering of the Old Testament heroine as the lewd "equivalent of a raw saloon nude."[123] But the artist's treatment of the theme within long-established conventions and his rendering of her body in a state of nature according with the landscape's fertile abundance, retains the biblical message of ultimate redemption. In counterpoint, the prodigal's return to a place of absence and loss reflects the artist's own skepticism about the possibility of spiritual attainment. Benton wrote that he sympathized with the revivalists' faith in a God who "talks matters over with his weak, erring, and suffering children." Why, Benton asked, "if we must fill the void of the unknown with a fiction, should it not be filled with a Being who possesses all those magnified attributes of man to which men as individuals so continuously and so hopelessly aspire."[124]

Estranged from the artistic community, Benton later recognized that Regionalism was out of place at a time when "our very survival as a nation was being menaced by what was occurring in Europe."[125] But observers by the later 1930s had already begun to speak of Regionalism "in the past tense. . . . a renaissance had not occurred."[126] While Modernism entered the American mainstream, Benton remained entrenched in the Realist tradition. Critics attacked his subject matter for its rusticity and his figures for their toy-like construction, verging on caricature. Milton W. Brown singled out Benton's painting of the *Prodigal Son* as evidence for the artist's failings when he used it as the only illustration for a scathing overview of Benton's 1941 exhibition at the Associated American Artists gallery in New York. The image served Brown's argument that the artist's approach to the American scene represented a retreat to ruralism. "What has Benton gained in his return to his Missouri roots?" Brown asked. "Where is

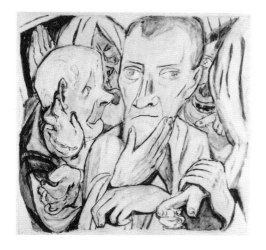

Fig. 5. Max Beckmann, *The Prodigal Son*, 1918, gouache and watercolor with pencil underdrawing on parchment. The Museum of Modern Art, New York. Purchase (not in exhibition)

blues song *Prodigal Son*, written by the Reverend Wilkins and recorded by the Rolling Stones in 1968.[129] "A poor boy with his father's bread" went out in the world and spent all he had. "I believe I'll go back home," he said. His father saw him and fell down on his knees:

Said "Save your breath,
Lord have mercy on me."
Poor boy, stood there,
hung his head and cried.
Hung his head and cried. . . .
Well father said to his eldest son,
"Kill the fatted calf.
Call the family 'round.
Kill that calf and call the family 'round:
My son was lost and now he is found
and that's the way for us to get along."

Duane Michals: "Bring forth the best robe"

And the son said unto him, Father, I have sinned against heaven, and in thy sight, and am no more worthy to be called thy son. But the father said to his servants, Bring forth the best robe, and put it on him; and put a ring on his hand, and shoes on his feet (Luke 15: 21–22).

Only when the penitent son was stripped of his clothing outside the father's house and appareled anew could he enter the haven of the Church, the place of eternal bliss. The prodigal's outer attire signifies his inner state: finery his worldly pride, rags his spiritual degradation, new garments his redemption. But the patriarch's garb is immutable. In the first and last scenes in popular narratives, he may wear identical clothing; in elevated art, his body is cloaked in magisterial robes. The father is immune to the vicissitudes of human experience.

In 1982, Duane Michals invented a narrative in five photographs in which the investment of the prodigal son with clothing acquires a highly-charged symbolism. Appropriately, it is by means of photography that an artist has recovered the printmaker's narrative format to reflect once again on the parable's message. Avoiding the familiar progression in time, Michals' filmic series, *The Return of the Prodigal Son* (No. 29), takes place, as the digital clock

28. Benton, *Return of the Prodigal Son*, 1939, lithograph

the American epic?"[127] Supporting his agenda in behalf of a proletarian art, Brown later stated that the irony of Benton's mural projects of the late 1920s had disappeared, only to be replaced by "quaint humor and native mythology. . . a kind of nationalistic romanticism."[128] In antagonizing both the academic establishment and those advocating socialist themes, Benton also distanced his work from the gathering forces of non-representational art. To produce a storytelling image about the prodigal's anxiety and alienation was to seek in literal narrative what emerging artists were discovering in abstraction. For Benton, like his prodigal son, going home to find resolution was an aspiration without hope.

But the parable's redemptive theme continued to retain a strong hold on the popular consciousness. This is perhaps no more movingly expressed than in the

29 a–e. Michals, *The Return of the Prodigal Son*, 1982,
set of 5 gelatin silver prints

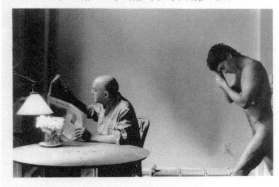
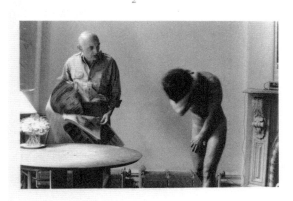
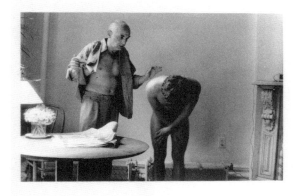
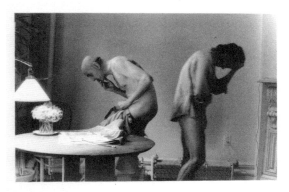
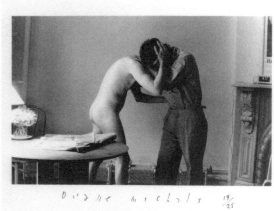

on the right indicates, during a period of no more than sixteen minutes. The balding, middle-aged man enacting the father is Duane Michals himself, then fifty years old. He sits at a table reading, far-sightedly, the *New York Times*. Light enters the shallow space from a window out of the frame to the left, and strikes the torso of a nude youth who, like an apparition, strides into the room from the right. Bending slightly, the youth bows his head in upheld hands to assume an iconic posture of shame. In the next scene, the father stands up and looks at the youth, who bends over and holds his arms between his legs. In the succeeding scenes, the father gradually divests himself of shirt and trousers to shield the son's bent body. At the end, entirely naked, he embraces the son. Departing from five centuries of tradition in Western literature, drama, and images, Michals enacts not the all-wise figure of authority, but a father who has leveled the ground. By giving up his own clothes, he bares himself to cover the son's shame. Kafka's returned youth asked himself if it were possible for secrets to pass between generations. For Michals' prodigal son, the father performs the ultimate act of self-revelation.

The power of the narrative derives from its dualities of observed fact and hidden or symbolic meaning. Just as many of Michals' fictions include myth and metaphor, so the carriers of his themes are often beautiful young men. Michals cast his prodigal in a dual role by referring, as he often does, to the Old Masters. In the first scene, the youth's nudity, cropped curling hair, striding posture, and hands held up toward brow recall the figure of Adam in Masaccio's *Expulsion from Paradise*, before 1428 (Florence, Brancacci Chapel).[130] Michals thus conflates the prodigal narrative with a mythic Renaissance work representing the story of the fall. A creature of the artist's re-imagining, the prodigal shares with Adam, with whom he has long been associated, a bodily language of shame. Michals rarely photographs himself in his narratives. In this case he not only did so, but in the fifth scene he took the unusual step—difficult, he points out,

for a man of his generation—of representing himself in the nude.[131] This was essential to Michals' belief that "empathy is the key" to his version of the prodigal's return. "My main impulse," he has stated recently, "was to put myself in the position of the son, who arrives defeated, nude, and vulnerable. The greatest thing you can do is to protect others." The father is neither the author of, nor a participant in, the son's shame. Yet he understands the extremity of pain that the experiences of life can cause. "There's a great wound in all of this—especially for young people who leave home undefeated."

Michals regards himself as a novelist or short-story writer, seeing all the subjects of his fictional narratives as forms of self-portraiture. But, like other authors and artists over the centuries, Michals found in the parable's narrative of a son's alienation from his parents an especially strong association with autobiography. "I knew my mother and my father my entire lifetime," Michals stated in a 1984 interview, "and not once did they ever reveal themselves to me. *The Return of the Prodigal Son* is very emotional because it deals with so many issues in my life: my complications with my father's relationship, these are compulsions which I can see. I've dealt with that subject before."[132] Michals' homosexuality, however, heightens the complexity of his parable's theme of generational conflict and resolution. In speaking of the series recently, he stated: "It worked the way I wanted it to work. Symbolically I wanted to play the mentor and the father with the person enacting the prodigal son." Michals' role as surrogate father to a young man, whose corporeal beauty and sexuality have no precedent in the history of prodigal son imagery, provokes the viewer to respond ambivalently to the final episode. For the embrace seems to express opposite poles of earthly love: parental and erotic. Max Kozloff touches on the tension implicit in the embrace: "The lovers appear before us as prisoners of each other, locked in ambiguous bondage…The dream of being a father to a youth is mingled with

attraction for the youth as a forbidden erotic object, creating a typical standoff, a natural impediment to desire."[133]

Michals' narrative insists on readings alternating between the universal and specific as the viewer scans the photographs for spiritual or profane meaning in peripheral details. Elements of time and location, for instance, are both real and elusive. Why did Michals place a clock on the mantelpiece to record the minutes elapsed during the drama? And why, in the first scene, does the artist hold up for the viewer's inspection the front page of the *New York Times*, thus making it possible to date it precisely to Monday, October 25, 1982? The artist has no answers for these questions. But a date for his series in the fall of 1982 raises a significant issue. During the year, the *Times* had published stories about a hitherto unknown immunodeficiency disease. On August 8th, more than two months before Michals produced his set, a reporter examined the phenomenon at length, stating that nearly half the nation's reported cases of the disease, later to be known as AIDS, were among gay men in New York City alone.[134] During 1983, the discourse on AIDS and homosexuality became increasingly polarized between those in sympathy with the stricken and those who saw in the disease God's punishment of sinners: transgressors of society's norms. Michals states that subject was not yet an issue in his thinking in 1982, and that his narrative sprang primarily from a need to explore problematic family relationships. But recently, the artist was reminded of the prodigal's story when speaking to a friend who was dying of AIDS. When Michals asked him if he had sources of support, he learned that the man—like so many with the same disease—was going home to his family. To revisit the narrative in the age of AIDS, when the specter of death has come to haunt human love, is to consider its redemption theme with renewed urgency.

Although Michals by no means minimizes the moral implications of shame, his parable is entirely absent of the key elements of sin and the granting of absolution. His work, as a whole, resists notions

of guilt or authoritarianism. Michals was brought up as a Catholic, but has explored non-Western beliefs and consciousnesses. He practiced Buddhist meditation for a period of years. Like Gide, Rilke, and many others, Michals rejects "all of those worlds which are essentially designed to make us feel comfortable" and, indeed, all religions that bear the freight of externally imposed doctrine. "Regret is a terrible emotion. It's debilitating, it's punishing, it's useless. . . . The word 'moral' bothers me. I think that judgment really is something that is self-punishing. . . . [That] which inflicts pain on yourself or somebody else, by nature is wrong."[135]

Michals' representation of the father as a mentor, clothing the son with his own garments, evokes not so much the Christian myth as a legendary sermon from the teachings of the Buddha that testifies to the presence of the prodigal theme in many cultures at many times. The Buddhist parable, found in the *Lotus Sutra*, tells of an impoverished man who finds Nirvana at the end of his journey toward enlightenment.[136] Having abandoned his father, a man of immense authority and riches, the man stays for many years in a far land where he humbles himself in abased labor and learns to renounce the desire for worldly possessions. At length he is reunited with the father, who soon assumes a disguise and does menial chores to establish common ground with his son. By coming to understand the son's humility, the father is able to teach him to become more self-assured and magnanimous on his path toward salvation. The father is the Buddha who, like the rich man, "knew that his son's ambitions were lowly" and who used his powers "to soften and mold his son's mind so that later he could entrust to him all his wealth and treasure."[137] At the father's deathbed, the son inherits all that the father owns, symbolic of the spiritual riches that are revealed to those who have not coveted them and who thereby reach the highest level of spiritual attainment. He is reborn in the spirit of the father, who "in his great mercy makes use of a rare thing, in pity and compassion teaching and converting, bringing benefit to us."[138] The burden of sin is absent in this Buddhist narrative in which the father is a wise and compassionate guide.

Ultimately, in Michals' fable, the prodigal's assumption of clothing makes vivid his assumption of the father's role. A new generation is appareled in the mantle of the old. On the eve of the millennium, an artist has reinvigorated the parable's archetypal theme of exile and the search for self that has made it so enduring a legend in the history of religion, literature, and art.

Notes

1 A useful bibliography of the prodigal son theme is given in Baldwin 1987, 167–71 (abbreviated references are cited in full in the Selected Bibliography). The narrative is related to the Buddhist parable about the rich man and his son in *The Lotus Sutra*; see n. 136.

2 Haeger 1983, 57–73, 107. On Calvin's and Luther's interpretations and those following into the seventeenth century, see ibid., 86, 106–07, 114, 172–74.

3 Vetter 1955, x–xvii; Haeger 1983, 11–16; a chronological listing of many early prodigal son images is contained in Young 1979, App. B, 290–99.

4 Haeger 1983, 27 and n. 28.

5 See Franz Spengler, *Der Verlorene Sohn im Drama des VXI. Jahrhunderts* (Innsbruck: Verlag der Wagnerschen Universitäts Buchhandlung, 1888).

6 Armstrong 1990, 24–25; Vetter 1955, xxviii–ix.

7 Young 1979, 281.

8 Yale's woodcut, illustrating a text printed in Latin and German, was probably produced in Augsburg in Southern Germany. For other examples of early autonomous return scenes of the 1470s in woodcuts, see *Illustrated Bartsch* 1978, 81: 37, 1476/121; ibid., 96, 1476/432; 254, 1477/214; for early cycles of five and six scenes, both of which include the prodigal's mother, see ibid., 81: 59–60, 1476/257–61; ibid., 83: 53, 1481/236–41.

9 Vetter 1955, xxii–xxv; and Kunzle 1973, 259, Fig. 9-2.

10 Panofsky 1971, 76; among the woodcuts of the subject probably known to Dürer is an image of the prodigal standing among swine feeding from a trough, published in Bernhard Richel's *Speculum humanae salvationis* (Basel, 1476), discussed in ibid., 76 and Fig. 105. Dürer's preliminary drawing, ca. 1496 (London, British Museum), lacks the steeple; his print inspired at least six contemporary copies (*Illustrated Bartsch* 1978, 10: 74, C1-6).

11 Although the prodigal stands among swine in woodcuts, he kneels in a Byzantine manuscript and in one of the Chartres stained-glass windows (Vetter 1955, xxvi, n. 73). He also kneels in the Marburg tapestry, ca. 1400–30 (Marburg, University Museum, formerly Elisabethkirche); see Haeger 1983, 13, 74–78; and Kunzle 1973, 258, and Fig. 9-1.

12 After Dürer, the kneeling pose among swine also became the norm in the decorative arts; e.g., see James Yorke, "A Chest from Cockfield Hall," *Burlington Magazine* 128 (February 1986): 85. The prodigal stands in Beham's set (cat. no. 3c), and sits under a tree in the sets by Abraham Bosse and Pietro Testa (cat. nos. 8 and 9).

13 This half-kneeling return, represented in a woodcut from a Netherlandish blockbook, *Speculum humanae salvationis*, before 1472, is the only such example known to this author in a print pre-dating Dürer's engraving; see a facsimile edition of the blockbook (Munich: R. Piper & Co., 1925), fol. 33 (Davison Art Center Collection), and Adrian Wilson and Joyce Lancaster Wilson, *A Medieval Mirror: Speculum humanae salvationis 1324–1500* (Berkeley: University of California Press, 1984), 169. The woodcut scene is paired with its Old Testament prefiguration: a scene of King David penitent before the prophet Nathan. The returned prodigal is on his knees in several medieval illuminations, in a panel of the Chartres stained-glass window, and in a tapestry, ca. 1475–85 (Baltimore, Walters Art Gallery); see Vetter 1955, xxvi, n. 73; and Young 1979, 32, 296.

14 Harbison 1969, 33; on Protestant exegesis of the parable in England in the sixteenth century, see Young 1979, 14–20.

15 Haeger 1986, 128.

16 Ibid., 129–31. For an extended discussion of the set in the context of its increasingly mercantile society, see Armstrong 1990, 88–104, Figs. 97a–f; and Kunzle 1973, 265–67, Fig. 9-7.

17 Among the best known of the early single-sheet prints are Lucas van Leyden's *Return of the Prodigal Son*, ca. 1510 (Bartsch 78), which includes earlier episodes in the composition, and Sebald Beham's engraving of the penitence scene, 1538 (Pauli 37). Beham's large woodcut from eight blocks, 1530, incorporates the departure, penitence, and return episodes in the background of the brothel scene (Pauli 831). Early serials following it are: Cornelis Anthonisz's six woodcuts, ca. 1535 (see n. 16); Beham's four engravings, 1540 (cat. no. 3); Martin Treu's twelve engravings, ca. 1540–42 (Bartsch 3–14); Dirk Volkertsz Coornhert's four woodcuts after Heemskerck, ca. 1548 (Hollstein 50–53); and Phillips Galle's set of six engravings after Heemskerck, 1562 (Hollstein 147–52), which concludes with an unusual scene of the older son remonstrating with his father.

18 For a discussion of Lucas's interest in peddlers, beggars, and peasants, see Jacobowitz and Stepanek 1983, nos. 23 and 78; the entry on Lucas's engraving, *Return of the Prodigal Son*, ca. 1510 (ibid., 94, no. 29), cites Charles de Tolnay's discussion of Hieronymous Bosch's *The Prodigal Son*, ca. 1510, oil on wood (Rotterdam, Museum Boymans-van Beuningen). Bosch's prodigal, formerly titled *The Peddler*, is "unable to choose between sin and virtue, because he lacks willpower and has no faith; the theme of the prodigal son is integrated into the allegory of decision by free will, a late medieval parallel to the theme of Hercules at the Crossroads" (*Hieronymous Bosch* [New York: Reynal, 1966], 283).

19 Beham's preliminary drawing for the return scene is in the Metropolitan Museum of Art, New York.

20 Stephen Goddard and essayists in his catalogue discuss the work of Beham and the Little Masters in relationship to the Reformation and peasant themes (Goddard 1988, 15–18, 141, no. 36; and 203–11, nos. 55–57); see also Larry Silver, "Less is More: the 'Kleinmeister' in Kansas," *Print Collector's Newsletter* 19 (January–February 1989): 214, 216.

21 Collaert's set is exhibited here in impressions printed on two sheets from the two plates before they had been cut in half. Collaert had earlier placed a diminutive prodigal under a tree in his *Cancer* (June) from the engraved set, *The Months*, 1585,

after Hans Bol (Hollstein 57). In one of Jacob Matham's five engravings, *Kitchen Pieces with Biblical Scenes in the Background,* ca. 1603, after Pieter Aertsen's panel paintings of 1552, the penitent prodigal assumes a semi-recumbent pose (Hollstein 322).

22 See Lisa Vergara, *Rubens and the Poetics of Landscape* (New Haven: Yale University Press, 1982), 143–44, and Pl. 95. Bolswert reproduced the composition in plate 5 of his engraved *Set of Large Landscapes* after Rubens (Hollstein 303). Similar in their emphasis on rustic farmyard settings are compositions such as Jan Saenredam's *The Prodigal Son Hiring Himself Out as a Herdsman,* ca. 1618, after Abraham Bloemart (*Illustrated Bartsch* 1978, 4: 334); Orazio Brunetti's engraving after a similar subject by Bloemart, ca. 1620–30; and Bloemart's painting *The Prodigal Son as a Swineherd,* 1637 (Blackheath, The Suffolk Collection, Ranger's House).

23 See Vetter 1955, xxvi. Van Mander's commentary in *Het Schilderboeck* (1604), trans. C. van der Wall (1936), is cited in Campbell 1970, 296 n. 19.

24 Lieure (1924–27, no. 596) states that the prodigal in the dissipation scene (cat. no. 6) is Callot's self-portrait, and identifies Callot's coat-of-arms in the seventh and ninth scenes of the 1635 set (ibid., nos. 1405–14).

25 Among drawings after Rembrandt's lost originals are two of the departure (cited in Campbell 1970, 294–95 nn. 10, 12); there are two drawings by Rembrandt of dissipation scenes (ibid., 296 n. 17), one with swine, and seven drawings, by and after Rembrandt, of the return (ibid., 297 n. 22).

26 Bergström 1966, 143–69.

27 Commentators have pointed to precedent for the embracing postures in prints after Maarten van Heemskerck, which were contained in an album owned by Rembrandt (Haeger 1983, 34 n. 42). These scenes were represented in a woodcut set attributed to Dirk Volkertsz Coornhert, ca. 1548 (Hollstein 53), and in an engraved set by Phillips Galle, 1562 (Hollstein 150).

28 Haeger 1983, 180–83.

29 The tapestry (see n. 11) was admired by Rainer Maria Rilke, as discussed in the text below.

30 For sexual symbolism associated with musical instruments in prodigal son images, see Leppert 1974, 85–90, and H. Colin Slim, "Images of Music in Three Prints by Maarten van Heemskerck," in *Iconography at the Crossroads*, ed. Brendan Cassidy (Princeton: Department of Art and Archaeology, Princeton University, 1993), 229–39.

31 Pauli 831. A painting that also gives prominence to the dissipation scene, with smaller scenes from the narrative in the background, is The Master of the Prodigal Son, *The Prodigal Son in the Tavern*, ca. 1550 (Vienna, Kunsthistorische Museum); see Bergström 1966, 154, Fig. 4.

32 Among the earliest of these are Lucas's woodcut *Tavern Scene*, ca. 1518–20, and Master PVL, *Men Playing a Game of Dice*, ca. 1520 (Jacobowitz and Stepanek 1983, nos. 72 and 129).

33 See the discussion of de Gheyn's engraving after

van Mander, in Clifford S. Ackley, *Printmaking in the Age of Rembrandt* (Boston: Museum of Fine Arts, 1981), 23; and Jan Kelch's discussion of Esaias van de Velde's oil, *Party on a Garden Terrace*, before 1620, in Sutton 1984, 328–30.

34 On the prodigal son parable and other subjects from the Bible and mythology as moralizing sources for merry company genre, see Sutton 1984, xxvii, xxiv–xxxiii, and Armstrong 1990, 19–24. The difficulty of interpreting these scenes is discussed by Stechow (1972, 165–74). Although most of the images of sinful humanity have moralizing intent, Cornelis Galle's engraving, before 1612, after Gerrit Pietersz. Sweelinck's painting, *Man Before the Flood*, ca. 1593, includes an inscription inviting spectators to "Join our company here; we have plenty of fun....mirth and play are our only desire" (Stechow 1972, 173). Svetlana Alpers sees this engraving— and related uninhibited works aimed at middle-class audiences—as "best understood in the context of the illustrations for contemporary song-books, whose prefatory words often issue a similar invitation to party pleasures" ("Realism as a Comic Mode: Low-Life Painting Seen Through Bredero's Eyes," *Simiolus* 8 [1975–76]: 126 n. 45; see also Leppert 1974, 81–91).

35 I am grateful to Andrew Szegedy-Maszak for these translations.

36 These engravings were by Goltzius, ca. 1580–95, after Hans Bol (Hollstein 18–21); Collaert, ca. 1588, after Hans Bol (cat. no. 4; Bergström 1966, 155, drawing, Fig. 5); Matham, 1592, after Karel van Mander (Hollstein 64–67); van de Passe, 1601, after Maerten de Vos (Hollstein 17–22ad, 112–117; Bergström 1966, 156, Fig. 6); Visscher, 1608, after David Vinckboons (Nagler 8; Bergström 1966, 158, drawing, Fig. 7); Sadeler, ca. 1610–20, after O. Fialetti (Hollstein 40–43); Gelle, ca. 1610–25, after August Braun (Hollstein 2–5); and Merian, 1612–13, after his own designs (Wüthrich 47–52).

37 Callot's set influenced those by Bosse and Testa, as well as the set of six etchings by de Wael, 1658, after Cornelis de Wael (Nagler 15), and the set of six engravings by Mauperché (Robert-Dumesnil 10-15), in which the father is identified as Ruben and the prodigal as Azael (see n. 43). The seated pose among swine was repeated by Francesco Amato in a single-sheet engraving in reverse, ca. 1656-70 (*Illustrated Bartsch* 1978, 47: 5, 207). Many Italian painters, such as Guercino (cat. no. 10), Matia Preti, Giovanni Benedetto Castiglione, and Salvator Rosa, represented autonomous penitence and return scenes.

38 See especially the title-page engraving of the prodigal in a tavern, probably by Jan Martz. de Jonghe, for the moralizing drama by W. D. Hooft, *Heden-daeghsche verlorenen soon*, Amsterdam, 1630 (Bergström 1966, 162–63, Fig. 11). Cornelis Anthonisz produced two serials in woodcut: *Careless (Sorgheloss)*, 1541, comprised of six elaborate scenes with moralizing texts, and *The Flighty Youth*, ca. 1535, two woodcuts (Armstrong 1990, 19–36, Figs. 37a–f, 24a–b; and Kunzle 1973, 262–67, Figs.

9-6 and 9-8). Among the many other such series were seventeenth-century Italian sets, described in Kurz 1952, 144–48. Connections between these serials and prodigal son dramatizations and prints are cited in ibid., 145, 151, 156, Fig. 35; see also Kunzle 1973, 272–95.

39 Kunzle 1973. Among the few narrative sequences in paintings are Bartolomé Esteban Murillo's six canvases of the prodigal son, ca. 1660–70 (Dublin, National Gallery of Ireland). These and their four oil studies (Madrid, Prado), are discussed by Taggard 1992, 9–66.

40 *The Fortunes and Misfortunes of the Famous Moll Flanders* (1722; reprint, New York: Modern Library, n.d.), vi.

41 *The Anatomy of Absurdity*, 1588, in *The Unfortunate Traveller and Other Works*, ed. J. B. Steane (New York: Penguin Books, 1985), 471. I am grateful to Ellen Chirelstein for this reference.

42 In addition to this painting of 1619 (Turin, Gallery Sabauda), Guercino also executed two other return scenes in about 1619 (Vienna, Kunsthistorisches Museum) and 1627-28 (Rome, Borghese Gallery); the latter was engraved in 1770 by Domenico Cunego for publication in Gavin Hamilton's *Scuola Italica Picturae*, 1773.

43 Taunay probably painted his set of gouaches after he returned to Paris in 1795 following the Terror. Precedent for his use of Egyptian and Grecian motifs and costumes, as well as his identification of Memphis as the place where the prodigal dissipates, is found in Mauperché's set of engravings, ca. 1650-60 (see n. 37).

44 Hogarth undoubtedly knew of European prodigal prints and possibly a British set: John Sturt's *The Prodigal Son*, 1678. Sturt's four engravings, which borrow from Callot, Rubens, and Bosse, were published in John Goodman's sermon, *The Penitent Pardoned*, 3rd ed. (London: R. Norton for Luke Meredith, 1689); see D'Oench 1990, Pl. 13.

45 The plagiaries (British Museum Catalogue 1873-83 [hereafter cited as BM Sat.], 2171 and 2172) are discussed by Kunzle 1966, 311–20. Hogarth's own use of pictures as commentary within pictures had precedent in European images of prodigals and rakes (see van de Velde's drawing of a tavern scene, 1629, with a penitent prodigal image on the wall, Bergström 1966, 161, Fig. 10); in Italian popular prints (Kurz 1952, Pl. 35 iv); and in such British examples as *The Prodigal Sifted*, a woodcut of about 1700 (BM Sat. 1407), in which cautionary rake scenes hang on the wall in the background.

46 In a letter to the author, 16 March 1994, Elizabeth Einberg, Tate Gallery, states that recent X-ray examination of the *Rake's Progress*, as of other Hogarth paintings, revealed "a mass of pentimenti" but no important changes to the subjects. The prodigal prints in the plagiaries are in the style of popular woodcuts dating about 1700-20.

47 The five printmakers were: Robert Gaillard (Pl. 1), Pierre-François Basan (Pls. 2 and 6), Jean-Christophe Teucher (Pl. 3), Jacques de Favannes (Pl. 4), and Pierre-Etienne Moitte (Pl. 5; British

Museum, Department of Prints and Drawings). De Larmessin advertised the publication in the *Mercure de France* (July 1751), 155.

48 See the discussion of Amos Doolittle's 1814 set, below. An estimate of twenty sets of copies is low: it includes neither the single sheets imitating Le Clerc's scenes, nor the many reissues of the plates, nor sets known from surviving single sheets (see Wolf 1979, and sets too numerous to cite in author's files), nor transfer prints from other British sets on decorative objects: e.g., the prodigal series printed on three Greatbatch Creamware teapots, recently sold at Christie's, New York, January 24, 1994 (lots 161–63). The earliest English sets were six engravings published by Robert Sayer, ca. 1752–55 (among the "cheap prints" in *Sayer and Bennett* 1775, 82, no. 4); mezzotints after the brothel scene by John Faber II, ca. 1752, and Thomas Ryley, ca. 1752-55 (Yale Center for British Art); Purcell's set, ca. 1752-55 (cat. no. 13), which was reissued in 1775 at one shilling for the set (*Sayer and Bennett* 1775, 16, no. 11); and three oil paintings, ca. 1760s (Henry Francis duPont Winterthur Museum, lacking the brothel scene). In Augsburg, Germany, at least three variant mezzotint sets after Le Clerc were published with English and German inscriptions about 1758-67 by the firm of Johann Jakob Haid and his sons (Yale Center for British Art).

49 *Carington Bowles* 1784, 156–58.

50 *Edmund Oliver* (1798, reprint Oxford and New York: Woodstock Books, 1990), 206. The prodigal prints comment on Oliver's earlier dissipation at Oxford and ultimate redemption.

51 *The Complete Prose Tales of Alexandr Sergeyevitch Pushkin*, trans. Gillon R. Aitken (New York: W. W. Norton, 1966) 107–08. The set was probably one of the many after Le Clerc issued by the Haid family firm in Augsburg during the 1760s and 1770s (see n. 48). As in a few late eighteenth-century popular sets, the father wears the same night cap and dressing gown in the first and last scenes. The stationmaster's daughter, brought up with these prints in her childhood, had eloped with her lover. Neither fallen nor ultimately forgiven, she married happily and later returned home with her children to find that her father had died.

52 Laurence Stone, *The Family, Sex and Marriage in England, 1500–1800* (New York: Harper & Row, 1977), 414.

53 Fliegelman 1982, 2–4, 12–23.

54 Quoted in Stone 1977, 413.

55 Ibid., 659.

56 Laurence Sterne, *The Sermons of Mr. Yorick*, 3 vols. (London: R. and J. Dodsley, 1766) 3: 323, 329 (the italics are Sterne's).

57 Rowlandson was the first to introduce the idea with his etched brothel scene, *The Prodigal Son*, ca. 1785 (Godfrey and Riely 1984, no. 84), which was copied by an unknown artist (The Lewis Walpole Library, Yale University). He returned to the subject in his etching *Filial Piety*, 1788 (BM Sat. 7378) and in a lampoon on the Duke of York, younger

brother of the Prince of Wales, as prodigal son (cat. no. 18). Gillray's *Reconciliation*, 1804 (cat. no. 17), the source of three copies (BM Sat. 10283A-C), was followed by his *Diamond Cut Diamond*, 1806 (BM Sat. 10592), in which three prodigal prints hang on the wall behind a jeweler holding the Prince's unpaid bills. Isaac Cruikshank also referred to the Prince as prodigal in an etching of 1793 (BM Sat. 8311) and to the Duke of York in the same vein (BM Sat. 11268).

58 Mathon de la Cour, quoted in Brookner 1972, 65.

59 Ibid., 73–74, Pls. 38, 39, 61, 62, and related studies, Pls. 45 and 63; see also Rosenblum 1970, 37–38.

60 J.-G. Taraval, who represented the returned prodigal standing upright, shared the first prize; see J. Depouilly, "Le 'Grand Prix' décerné en 1782 à Jean-Gustave Taraval," *Revue du Louvre* 30 (1980): 183–84. An unusual neoclassical composition of the return scene, Jean-Germain Drouais' *Prodigal Son*, also executed in 1782 (Paris, St. Roch; Rosenblum 1970, Pl. 48), represents a draped woman on her knees before the seated returned son. The older brother, a hunched figure, displays a clenched fist. British neoclassical interpretations of the subject as emotion-charged imagery included paintings by Benjamin West, whose *Return*, exhibited at the Royal Academy in 1771 (215), was reproduced in mezzotint by John Young in 1789. West exhibited another version of the scene at the Royal Academy in 1773 (307).

61 Frederick Antal, *Hogarth and His Place in European Art* (London: Routledge & Kegan Paul, 1962), 199. Also corresponding to Greuzian ideals of *sensibilité* was John Hamilton Mortimer's four-part drama in classical dress, *The Progress of Virtue,* exhibited in 1775 at the Society of Artists (see Kunzle 1973, 340, Fig. 11-1).

62 *Carington Bowles* 1784, 109, no. 218, and *Bowles and Carver* 1795, 99, no. 232.

63 Among the rare examples of the prodigal recumbent is a woodcut illustrating Meder's sermon (see n. 9) in which the crying youth lies on his back on the ground, while consoled by his guardian angel (Vetter 1955, xxv). A later example of the pose is found in a print within a print by Smith's friend, Thomas Rowlandson, *Return from Scotland*, 1785 (BM Sat. 9669), a satire on a young couple's return to the father's house after their elopement to Gretna Green. The returned prodigal also stands in a 1792 set of four mezzotints after Robert Dighton (British Museum, Department of Prints and Drawings) and within a series of images from a single engraved plate, *The Parable of the Prodigal Son* (The Lewis Walpole Library, Yale University). About 1770, Perdoux in Orléans printed separate scenes of the parable from a single wood block (Adhémar 1968, Pl. 63).

64 For a comprehensive discussion of the Magdalen, see Haskins 1993. Van Dyck's paintings of the Magdalen and prodigal son before Christ are cited in ibid., 254–55. Haskins traces the accretion of willful misinterpretations, suiting the purposes of Church authorities, that established erroneous leg-

ends about the Magdalen as a redeemed whore.

65 See D'Oench 1990, 328–33, and Haskins 1993, 236, 298, 304–09, and her chapter on Mary Magdalen as "The Weeper," 229–96. Late eighteenth-century and early nineteenth-century feminized or androgynous male nudes in French art, frequently supine, are discussed in Abigail Solomon-Godeau, "Male Trouble: A Crisis in Representation," *Art History* 16 (June 1993): 286–312.

66 Typical of the sets are the anonymous artist's *A Modern Harlot's Progress or Adventures of Harriet Heedless,* 1780, six engravings (BM Sat. 5808–13); John Young, *Credulous Innocence* and *Seduction,* 1788, after Morland, two mezzotints; Maria C. Prestel, *The Country Girl in London,* 1792, after Morland, etching and aquatint, published by E. M. Diemar (both British Museum, Department of Prints and Drawings); Thomas Gaugain and Thomas Hellyer, *Diligence and Dissipation,* 1796, after James Northcote, ten etchings and engravings; and Anthony Cardon, *Progress of Female Virtue* and *Progress of Female Dissipation,* 1800, after Maria Cosway, sixteen etchings and aquatints (both Yale Center for British Art).

67 Smith (ca. 1797, 6, no. 209) identified the set as *Six of Seduction,* for sale at the relatively high price of two pounds five shillings. The narrative is thought to be Smith's own invention which he suggested to Morland as the basis for Morland's paintings, 1786 (Christie's, April 16, 1982, lot 102). Surviving complete sets are now rare. Having worn down by 1811, the plates were reworked, the costumes and hairdresses updated, and sentimental verses added for a new publication by R. Ackermann (British Museum, Department of Prints and Drawings). In addition to the "Bartolotti" copies in reverse (cat. no. 19), the set was copied in engravings by A. Gabrielli, ca. 1790s (Pls. 4 and 5, British Museum, Department of Prints and Drawings), and in aquatint by J. P. Cook, 25 July 1792 (Norman Blackburn Collection).

68 *Gentleman's Magazine* (January 1796), 9. Stevenson also mentioned the print's pendant by Quinton after Duché, *Asylum for the reception of Female Orphans,* then in progress.

69 Among the numerous tracts about the hospital in the British Library is Robert Dingley's *Proposals for Establishing a Public Place of Reception for Penitent Prostitutes* (London: W. Faden, 1758). See also a discussion on the hospital in Haskins 1993, 309–16. Associations between the prodigal son and prostitute abound in sermons by William Dodd, published in his *An Account of the Rise, Progress, and Present State of the Magdalen Hospital,* 5th ed. (London: W. Faden, 1776), 21, 22, 28, 41, 157, and 251. Its engraved frontispiece represents an inmate in hospital uniform.

70 For the shift in attitudes from the 1790s to 1810, see Edward J. Bristow, *Vice and Vigilance: Purity Movements in Britain Since 1700* (Dublin: Gill and Macmillan, Ltd., 1977), 35–55; Muriel Jaeger, *Before Victoria* (London: Chatto & Windus, 1956), 14–52; and David Owen, *English Philanthropy, 1660–1960*

(Cambridge, Mass.: Belknap Press of Harvard University Press, 1964), 97–105.

71 *Strictures on the Modern System of Female Education,* 2 vols. (1799; Philadelphia: Thomas Dobson, 1800) 1: 54.

72 Nochlin 1978, 223. Nochlin refers to an anonymous series of twelve wood engravings for *La Vie d'une femme,* 1836, published by Pillot, and Jules David's lithographic scenes in *La Vie d'une jolie fille,* 1847 (pendant to *La Vie d'un joli garçon),* ibid., 224–25, Figs. 4, 5.

73 Ibid., 223, 225.

74 Wentworth (1978, 245 n. 4) cites a set of four French prodigal engravings by Duthé after Auguste Legrand, ca. 1800–10 (unlocated), in which the figures wear Directoire costume. Single-sheet images of the prodigal persisted in European popular woodcuts, such as a return scene, ca. 1820–38, published by Desfeuilles in Nancy (Adhémar 1968, Pl. 114).

75 The earliest set, by William Priest, published in Philadelphia about 1796, was followed by a set of reversed copies after a 1794 Laurie & Whittle publication, London (Henry Francis duPont Winterthur Museum), and two anonymous sets of engravings, dating about 1805–15 (Wolf 1979, 147–48, 159–69).

76 The 1799 set (recently acquired by The Lewis Walpole Library, Yale University) was published by Haines & Son, Fetter Lane, London (see *The Old Print Shop Portfolio* 54 [New York, 1994], Pl. 55). Unaware of the Haines set, Wolf (1979, 165) cites a nearly identical set in reverse, published in London in 1805 by W. B. Walker, as a source for Doolittle's series.

77 For the Kellogg series, see Steinway 1988, 4. Hand-colored impressions of the Kellogg and Alden lithographs are owned by the Yale University Art Gallery.

78 The address given on the Currier set dates it at the earliest to 1838, when Currier opened his printshop at 152 Nassau and 2 Spruce Street, New York (Currier & Ives 1984, 1: xvi, xxi). The set may have been executed close in date to Currier's pair of *Good Samaritan* lithographs, 1849 (ibid., nos. 2650, 2651). A set of prodigal lithographs, ca. 1840, was published by H. R. Robinson of New York and Washington, D.C. (Wolf 1979, 169).

79 Karen Halttunen, *Confidence Men and Painted Women: A Study of Middle-Class Culture in America, 1830–1870* (New Haven: Yale University Press, 1982), 12, 21. I am grateful to Elizabeth Milroy for this reference and for the reference to Sarah Burns' discussion, n. 82.

80 Ibid., 20, 193; after 1830, the numbers of advice manuals increased.

81 See, for example, the title page for *The Secrets of the Great City,* 1868, ibid., 38.

82 See Sarah Burns, "The Country Boy Goes to the City: Thomas Hovenden's 'Breaking Home Ties' in American Popular Culture," *The American Art Journal* 20 (1988): 59–73, and especially 60–63.

83 For the great increase in religious subjects during the Bourbon regime and a corresponding interest in

prodigal son themes, see Albert Boime, *Thomas Couture and the Eclectic Vision* (New Haven and London: Yale University Press, 1980), 95–100. Having painted a melancholic prodigal in about 1841, Couture returned to the theme in about 1873 with a drawing of the prodigal eating from the swine's trough. Couture wrote that he associated the prodigal's humiliation with that of his fellow countrymen in the aftermath of the Franco-Prussian war (ibid., 486–87, 623 n. 82). I am grateful to Elizabeth Milroy for this reference.

84 *Art Journal* 54 (1869), quoted in George P. Landow, "William Holman Hunt's 'Oriental Mania' and His Uffizi 'Self-portrait'," *Art Bulletin* 64 (December 1982): 652 and Pl. 11.

85 Legros executed six other prodigal prints similar to cat. no. 25 (Poulet-Malassi & Thibaudeau 66, 371, 399, 400, and 467). Day's triptych photograph, taken of a model in a Maine landscape, is discussed in Estelle Jussim, *Slave to Beauty: The Eccentric Life and Controversial Career of F. Holland Day* (Boston: David R. Godine, 1981), 191–92, Pl. 54.

86 Wentworth 1984, 39–41, Pls. 14, 16.

87 See Hector de Callias in *L'Artiste*, quoted in the Christie's sales catalogue entry for *Retour de l'enfant prodigue*, 1862, 12 June 1992 (117), 106. Cham produced a caricature of the painting in his *Salon de 1863* (Wentworth 1984, 39–40).

88 Stephens, writing in the *Atheneum*, quoted without date in Christie's sales catalogue, 12 June 1992, 106. Tissot's study for the prodigal is reproduced in David S. Brooke, Michael Wentworth, and Henri Zerner, *James Jacques Joseph Tissot, 1836–1902, A Retrospective Exhibition* (Providence: Museum of Art, Rhode Island School of Design, 1968), no. 40, Pl. 40.

89 Wentworth 1978, 244–45, nos. 57–61, and Pls. 58a–61a. In 1884, incidentally, Claude Debussy at the age of twenty-two, won the Prix de Rome prize for his cantata, *L'Enfant prodigue*.

90 Tissot modeled the figure of the sister on his common-law wife, Kathleen Newton, who appears in many of his compositions after 1876. See Wentworth 1984, 149–50.

91 Curiously, the literature on Tissot's 1881 prodigal set does not mention the artist's departure from tradition; indeed, the man coming up the steps is identified as the prodigal son, rather than the older brother, by Christopher Wood, *Tissot: The Life and Work of Jacques Joseph Tissot, 1836–1902* (New York: Little Brown, 1986), 116. Among the few narratives to give a separate scene to the father and older brother's discourse is Galle's sixth plate in his set of engravings after Heemskerck (see n. 17).

92 Haeger 1983, 172–78.

93 Wentworth points this out, stating that it is "hard to think of the cautious Tissot in terms of his thriftless Victorian" prodigal son (1984, 150).

94 Ibid., 148–49 and Appendix VI; and see Matyjaszkiewicz, ed. 1984, 133–35. The paintings were later transferred to the Musée des Beaux-Arts, Nantes.

95 Ian Thomson, "Tissot as a Religious Artist," in

Matyjaszkiewicz, ed. 1984, 91. See also the catalogue entry on drawings from the set (ibid., no. 181). Tissot was made Chevalier of the Legion of Honor following the 1894 exhibition. For a discussion of Tissot's mystic neo-Catholicism and his later religious works, see Willard Erwin Misfeldt, "James Jacques Joseph Tissot: A Bio-Critical Study" (Ph.D. diss., Washington University, St. Louis, 1971), 236–89.

96 Wentworth notes this replication (1984, 149); see J. James Tissot, *The Life of Our Saviour Jesus Christ*, trans. Mrs. Arthur Bell, 3 vols., 5th ed. (New York, ca. 1900) 2: 247, 250. Lavishly illustrated with color photolithographs, the series, accompanied by passages from the gospels, was first reproduced in a deluxe French edition (1896–97), and in an English edition (1897); see Thomson in Matyjaszkiewicz, ed. 1984, 91–92.

97 Thomson in Matyjaszkiewicz, ed. 1984, 92.

98 Misfeldt 1971, 248.

99 Faxon 1982, 13, 22–27.

100 Ibid., 63.

101 Ibid., 66, referring to Faxon no. 154 in which the house represents Forain's at Le Chesnay; the other departure scenes are Faxon nos. 155 and 156.

102 Gide's parable was published in *Vers et Prose*; see Gide 1971, 378–93; see also Littlejohn's discussion in ibid., 305–06.

103 John Russell, ed. *The Correspondence, 1899–1926, Between Paul Claudel and André Gide* (London: Secker & Warburg, 1952). Gide believed that the essay would jeopardize his friendship with Claudel. But Claudel (ibid., 71–73), taking care not to cause a rupture, wrote a gentle reprimand, telling Gide not to run away from "the disagreeable side of life" and reminding him of the "happiness of responsibility."

104 Gide wrote this of Claudel and Francis Jammes who were scandalized by homosexual undertones in the train scene in Gide's *Lafcadio's Adventures (Les Caves du Vatican)*, 1914 (ibid., 219).

105 For a discussion of the struggle between Christian and pagan values in Gide's work, see Patrick Pollard, *André Gide: Homosexual Moralist* (New Haven: Yale University Press, 1991).

106 Rilke read Gide's parable in translation in *Neue Rundschau* in 1907 (Renée Lang, ed., *Rainer Maria Rilke, André Gide: Correspondence 1909–1926* [Paris: Correa, 1952], 37–39, 76–78). Following the publication of *Malte*, Rilke sent a copy to Gide (ibid., 40–41). See also Joan E. Holmes, "Rodin's 'Prodigal Son' and Rilke's 'Malte'," in Baron, ed. 1982, 19. Rilke worked on his own translation of Gide's *L'enfant prodigue* in 1913 and 1914, when it was published in Berlin by Insel-Verlag (Lang, ed. 1952, 72, 76–92).

107 Rilke 1984, 153.

108 *Rainer Maria Rilke: New Poems*, ed. and trans. J. B. Leishman (New York: New Directions Publishing Corporation, 1964), 67. I am grateful to Arthur S. Wensinger for pointing out this poem, written in Paris in June 1906, and for the Kafka reference cited below.

109 Jennifer Liebnitz discusses the influence of the tapestry on Rilke's use of motifs and simile in "The Image of the Prodigal Son in Rilke's Poetry," in Baron, ed. 1982 11–17. The tapestry is mentioned earlier in the present text (see n. 11).

110 From the *Duino Elegies*, 1922 (Rilke 1984, 229).

111 Nahum N. Glatzer, ed., *Franz Kafka: The Complete Stories*, trans. Tania and James Stern (New York: Schocken Books Inc., 1971), 445–46.

112 For reproductions of these works, see: Eric Shanes, *Constantin Brancusi* (New York: Abbeville Press, 1989), 54; Johannes Sievers and Emil Waldman, *Max Slevogt: Das druckgraphische Werk* (Heidelberg: Impuls Verlag Heinz Moos, 1962), no. 478; Paul Vogt, *Christian Rohlfs: Das graphische Werk* (Recklinghausen: Verlag Aurel Bongers, 1960), no. 99; William Rubin, et al., *Giorgio di Chirico* (Munich: Haus der Kunst, 1982), 48, 194, and Fig. 17; Peter White, *Sybil Andrews* (Calgary: Glenbow Museum, 1982), no. 42, Pl. 16; Edward A. Jewell, "Albert Sterner's Prints," *Print Collector's Quarterly* 19 (1932): 262; the soft-ground etching and drypoint represents the father at a table and, across from him, the prodigal with head bowed in hands. Julius Komjati's etched *Return*, ca. 1920–25, represents the father wearing a Forainesque fur-collared overcoat (Kenneth M. Guichard, *British Etchers 1850–1940* [London: Robin Garton, 1981], Pl. 39). Other prodigals include two etchings by Frank William Brangwyn, 1910 (Gaunt 1926, nos. 163, 163A); a wood engraving by Eric Gill, 1931; an etching by Norbert J. Schaal, 1931 (Jerry Evenrud Collection); linoleum cuts by Robert Hodgell of 1960 and 1965 (Jerry Evenrud Collection); and a folk-inspired woodcut of a prodigal among swine by Fritz Eichenberg, 1967 (Davison Art Center). Among the more pessimistic images are Alfred Kubin's lithograph of the prodigal in despair, seated near a train station, 1923 (Paul Raabe, *Alfred Kubin: Leben, Werk, Wirkung* [Hamburg: Rowalt Verlag, 1957], 115, no. 221); and a murky drypoint of the prodigal with swine by Lovis Corinth, 1924 (Heinrich Müller, *Die Späte Graphik von Lovis Corinth* [Hamburg: Lichtwarkstiftung, 1960], 855).

113 For Pascin's other prodigal prints, see Hemin et al. 1990, nos. 115, 135, 137, and 146.

114 The ballet opened at the Théâtre Sarah Bernhardt in Paris on 21 May 1929. Two of Rouault's surviving works, titled *Design for Decor for Ballet: The Prodigal Son*, 1929, watercolor and pastel (Hartford, Wadsworth Atheneum), represent a banquet table in a tent and a view of a Middle-Eastern mosque and minaret beside a body of water (James Thrall Soby, *Georges Rouault* [New York: Museum of Modern Art, 1945], 81, 132).

115 Bernard Taper, *Balanchine* (New York: Macmillan, 1974), 117. The ballet was revived in 1950 for Balanchine's New York City Ballet. Edward Villella, closely associated with the role, describes his first performance in 1960–61 in his book, written with Larry Kaplan, *Prodigal Son: Dancing for Balanchine* (New York: Simon & Schuster, 1992), 77–84, 199–211.

116 Quoted in Taper 1974, 120. Diaghilev died three months later.

117 Four of the five surviving drawings (approximately 14 1/2 x 11 3/4 in.) are owned by the Museum of Modern Art, New York; the fifth (the brothel scene) is in the Folkswang Museum, Essen. I am grateful to Robert Evren, Museum of Modern Art, for study photographs and for a photocopy of the brothel scene. In a letter to the author, 13 April 1994, Evren states that all five drawings were listed in the Essen museum's 1929 collection catalogue. They were seized by the Nazis in 1937 and sold; the brothel scene was later reacquired by the Folkswang Museum. The departure scene, which probably once existed, is lost. The series is discussed by Cornelia Stabenow in Carla Schulz-Hoffmann and Judith C. Weiss, eds., *Max Beckmann Retrospective* (Saint Louis: The Saint Louis Art Museum in association with Prestel-Verlag, Munich, 1984), 308, no. 120. For a discussion of Beckmann's technique in the prodigal among thieves drawing, see John Elderfield, *The Modern Drawing, 100 Works on Paper from the Museum of Modern Art* (New York: The Museum of Modern Art, 1983), unpaginated.

118 Stated by Stabenow 1984, 308. The prodigal's face is closely similar to the artist's drypoint self-portrait, 1920 (ibid., 411 and no. 269).

119 St. Louis, February 9, 1949, quoted in Stephan Lackner, *Max Beckmann* (New York: Harry N. Abrams, Inc., 1977), no. 43; also cited by Stabenow 1984, 308.

120 Benton's notes were written for the catalogue raisonné of his prints, first published by Fath in 1969, and revised in 1979 (Fath 1979, no. 29). Polly Burroughs, citing Benton's oil sketch, *The Flanders' House*, 1921, locates the house elsewhere in Chilmark in her *Thomas Hart Benton: A Portrait* (Garden City, NY: Doubleday & Co. Inc., 1981), Pl. 17 and caption for Pl. 28.

121 Most of the literature on Benton's oil and tempera on canvas (26 1/8 x 30 1/2 in.), ignoring the print, dates the painting to 1943. More accurate is the date of 1941 supplied by Gambone (1989, 255 n. 19), who discovered a reproduction of the painting in Milton W. Brown's 1941 review of Benton's exhibition at the Associated American Artists Gallery, New York (Brown 1941, 194). The painting may have been completed in 1940 (the date given by Fath 1979, no. 29), since the exhibition was installed by April 4, 1941 (Henry Adams, *Thomas Hart Benton, An American Original* [New York: Alfred Knopf, 1989], 303).

122 The subject is discussed in detail by Gambone 1989. John Steuart Curry, for instance, produced a watercolor, *The Prodigal Son*, 1929 (location unknown), representing a Kansas farm youth shoveling husks to swine (ibid., 28, Fig. 1.12).

123 Ibid., 20; for a discussion of public outrage over *Susanna* and *Persephone*, 1939, both exhibited at Benton's first Associated American Artists gallery exhibition in April 1939, see Adams 1989, 284–94.

124 From an undated manuscript, titled by Benton "What I Think," quoted in Gambone 1989, 15.

125 Quoted from Benton's statement of 1951 in ibid., 213.

126 Matthew Baigell, *Thomas Hart Benton* (New York: Harry N. Abrams, 1974), 78.

127 Brown 1941, 193.

128 Milton W. Brown, *American Painting from the Armory Show to the Depression* (Princeton: Princeton University Press, 1955), 191 and 195. I am grateful to Elizabeth Milroy for this reference and for her observations on Benton.

129 On the album *Beggar's Banquet*, reissued as ABKCO audiocasette 75394 / AC1T-04213. Elisabeth Hodermarsky kindly pointed out and transcribed this reference. Robert C. Lancefield has cited an ironic take on the return narrative in Michelle Shocked's song, *Prodigal Daughter (Cotton-Eyed Joe)*, from her *Arkansas Traveler*, 1992, issued by Polygram Records, Inc., audiocasette D110521.

130 In Masaccio's rendering, Adam walks in from the left, his left leg advanced, and his face nearly obscured by his hands; see Paul Joannides, *Masaccio and Masolino: A Complete Catalogue* (New York: Harry N. Abrams, Inc., 1993), 117 and Pl. 80. Among Michals' many uses of mythic associations are his allegories *The Unfortunate Man*, 1976, *The Bewitched Bee*, 1986, and *The Terrible Moment*, 1988, and his biblical subjects, *The Fallen Angel*, 1968, *The Apparitions: Adam and Eve*, 1971, and *Christ in New York*, 1981 (see Kozloff 1990, unpaginated), and Duane Michals, *The Nature of Desire* (New York: Twelvetrees Press, 1986).

131 Unless otherwise noted, this and other statements by the artist are quoted from a telephone interview with the author, 9 July 1994. To photograph the scenes, Michals used a self-timer on the camera, which was mounted on a tripod.

132 Quoted from Michals' 1984 interview with Marco Livingston in *Duane Michals: Photographs. Sequences. Texts* (Oxford: Museum of Modern Art, 1984), unpaginated. In touching on family relationships in the 1994 interview with this author, Michals states that these are still "deep, complicated issues." He is at present engaged in writing dialogues in which a son asks his father questions that Michals himself would want to be asked.

133 Kozloff 1990, unpaginated.

134 Robin Herman, "A Disease Spread Provokes Anxiety," *New York Times* (August 8, 1982), A31, col. 1. There were six articles in the *Times* on the subject in 1982, all listed under the heading "Immune System" in the newspaper's index. Two of the articles (on May 11 and July 19) referred to intravenous drug users and Haitians as at risk; Herman's article emphasized that the gay community was most seriously affected. The 130 articles in the *Times* in 1983 were categorized, by this time, as Acquired Immune Deficiency Syndrome. I am grateful to former Wesleyan University student, David J. Drogin, for tracing on microfilm the issue of the *Times* shown in Michals' first scene and for the above information.

135 Interview with Livingston 1984, unpaginated.

136 Following a period of oral tradition, the parable appeared in Sanskrit by the end of the first century, possibly as early as 40 CE, according to Hajime Nakamura's *Indian Buddhism: A Survey with Bibliographical Notes* (Hirakata City, Japan: Kansai University of Foreign Studies, 1980), 187. The first Chinese translation was made about 255 CE (*Lotus Sutra* 1993, ix). Watson's translation of the scripture, from the Chinese version by Kumarajiva, dated 406, is contained in Chapter 4, "Belief and Understanding" (ibid., 80–96). I am grateful to Elisabeth Hodermarsky for pointing out the Buddhist parable in Watson's translation. She believes that Michals' parable is associated with the Buddhist version through the element of time (the impossibility of measuring the immeasurable), the bending postures of both father and son, and the giving of clothing. This act, symbolic of coming to enlightenment and the son thus "becoming" the father, is a key element in the Buddhist parable that differs from the Christian version in which the son, although redeemed, can never succeed the father. Phillip Wagoner kindly supplied bibliographic sources, including a discussion of a related Indian narrative about exile, renunciation, and the spiritual rebirth of the hero—a legend that traveled from East to West—by Monique B. Pitts, "Barlaam and Josephat: A Legend for All Seasons," *Journal of South Asian Literature* 16 (Winter, Spring 1981): 3–16.

137 *Lotus Sutra* 1993, 94.

138 Ibid., 95.

Checklist of the Exhibition

Dimensions are of the block or platemark in milli-
meters; height precedes width. Abbreviated sources are
cited in full in the Selected Bibliography. Inscriptions
are supplied only for textual material related to the
prodigal narrative.

The prodigal son tradition

1
Anonymous (German, 15th century)
Return of the Prodigal Son, ca. 1475
Woodcut with hand coloring, 105 x 136
Text on sheet above image: *Filius pdigus
recevens in regionem longinquam/necessitate
compassus egit penitentiam. Luce-xv-ca./Der
verloren sun zauch in eyn verkungkreich
vnd/als in nott anstieß da worcht er
Bußwärtigkeyt.*
Yale University Art Gallery,
Gift of E. B. Greene, B.A. 1900
1928.358

2
Albrecht Dürer (German, 1471–1528)
The Prodigal Son Amidst Swine, ca. 1496–97
Engraving, 248 x 189
Bartsch 28
Davison Art Center, Gift of George W.
Davison (B.A. Wesleyan 1892), 1938
1938.D1.13

3 a–d
Sebald Beham (German, 1500–1550)
The Prodigal Son 1540
Set of four engravings, each
approx. 58 x 93
a. *Departure of the Prodigal Son*
Inscr.: PATER DA MIHI PORCIONEM
SVBSTANCIAE, QVAE AD ME REDIT.
b. *The Prodigal Son Feasting*
Inscr.: DISSIPAVIT SVBSTANCIAM SVAM
VIVENDO LUXURIOSE. LVCE. XV.
c. *The Prodigal Son Reduced to a Swineherd*
Inscr.: CVPIEBAT IMPLERE VENTREM
SVVM DE SILIQVIS]. LVCE. *XV.*
d. *The Return of the Prodigal Son*
Inscr.: FILIVS MEVS MORVVS ERAT, ET
REVIXIT, PERIERAT, ET INVENTVS EST,
LVCE. XV.

Pauli 33–36 (a–b, v/v; c, iv or v/v; d,
ii/iv); Hollstein, p. 30
Museum of Art, Rhode Island School of
Design, Gift of the Fazzano Brothers
84.198.624a–d

4 a–d
Adriaen Collaert (Flemish, 1560–1618)
The Parable of the Prodigal Son, ca. 1588,
after Hans Bol (Dutch, 1534–1593)
Set of four engravings printed on
2 sheets, 268 x 180
Hollstein 90–93
Davison Art Center, Gift of George W.
Davison (B.A. Wesleyan 1892), 1939
1939.D1.164 and .165

5
Johannes Sadeler I
(Flemish, 1550–ca. 1600)
*A House of Ill-Fame (The Prodigal Son
Wasting His Fortune)*, 1588, after Jodocus
van Winghe (Flemish, 1544–1603)
Engraving, 379 x 451
Inscr. below image: VINVM ET MVLIERES
APOSTATARE FACIVNT SAPIENTES. ET
QVI SE IVNGIT FORNICATORIIS ERIT
NEQVAM. *Sirach 19.*
Inscr. on plaque, u.l.: VENITE ET
E[R?]VAMUR BO-/NIS QVAE SV[N]T, ET
VTAMVR/CREATVRA TANQVAM
IN/IVVENTATE CELERITER
Inscr. on plaque, u.r.: NEMO VESTRV
EXORS SIT LVX-/VRIAE NOSTRE
VRIQVE RELIN-/QVAM SIGNA LETITIAE
QVO-/NIA HAEC EST SORS NOSTRA
Hollstein 559
Davison Art Center, Purchase funds, 1970
1970.40.1

6

Jacques Callot (French, 1592–1635)
*The Prodigal Son Cheated at Cards
(Le Brélan),* ca. 1628
Etching and engraving, 242 x 311
Inscr. in oval border: FRAVDI NATA
COHORS IVVENEM CIRCVMVENIT
ASTV PELLICIS. HINC MODVLIS
LVDITVR, INDE DOLIS. PERDIT OPES,
LVXV, FAMAE NEC PARCIT AVITAE.
PRODIGVS HINC SECVM NOMINA
LARGA TRAHIT.
Lieure 596 ii/ii
Davison Art Center Collection, Gift of
Henry-Russell Hitchcock, 1941
1941.3.4

7

Rembrandt Harmensz. van Rijn
(Dutch, 1606–1669)
The Return of the Prodigal Son, 1636
Etching, 157 x 134
White and Boon 91
Davison Art Center, Gift of George W.
Davison (BA Wesleyan 1892), 1938
1938.D1.50

8

Abraham Bosse (French, 1602–1676)
Festivities after the Return of the Prodigal Son,
ca. 1636–40
Engraving, plate 6 from the set of six,
250 x 314
Inscr. below image in four colums: *Dans ce
riche logis, où la ioye est extreme/On parle
seulement de ieux et de balets;/Et ce fils, qui
tantost estoit valet luy mesme,/A maintenant
soubs luy quanitités de vallets./Il iouit à
souhait des richesses acquises/Par l'autheur de
son bien, et de son bon destin;/Qui cherche à le
traitter de viandes exquises,/Et fait en sa
fanieur un Superbe festin/La se font remarquer
les plus douces merveilles,/Que puisse inventer
les Esprits curieux,/Lon y flatte le goust, lon y
plaist aux oreilles,/Et par de beaux objets on y
charmes les yeux./De ses preparatifs le sclat est
magnifique./Comme dans un Palais ou chacun
fait la cour;/Et tant y retentit de concerts de
Musique,/Pour rendre solonnel un si fameux
retour.*
Blum 1189
Yale University Art Gallery, Everett V.
Meeks, B.A. 1901, Fund. 1958.9.13

9 a–d

Pietro Testa (Italian, 1612–1650)
History of the Prodigal Son, ca. 1645
Set of four etchings, each
approx. 208 x 293
a. *Departure of the Prodigal Son*
Inscr. l.l.: *L'Historia/Del Figliolo prodigo*
b. *The Prodigal Son Dissipating His Wealth*
c. *The Prodigal Son Guarding Swine*
d. *Return of the Prodigal Son*
Cropper 95–98; Bellini 21–24 i/ii;
Bartsch 5–8
Sterling and Francine Clark Art Institute
1987. 8-11

10

Honoré Louis Gautier d'Agoty
(French, 1746–after 1775)
Return of the Prodigal Son, ca. 1770–75,
after Guercino (Italian, 1591-1666)
Mezzotint printed in color with hand
coloring, 352 x 391
Singer 2 i/ii; Franklin 1977, 52
Davison Art Center, Friends of the
Davison Art Center funds, 1984
1984.22.1

11 a–b

Charles-Melchior Descourtis
(French, 1753–1820)
L'Enfant prodigue, ca. 1795–1805,
after Nicolas-Antoine Taunay
(French, 1753-1820)
Two etchings and engravings, with
roulette, and mixed intaglio methods
printed in color, plates 1 and 2 from
the set of four, 310 x 441
a. *Le départ de l'enfant prodigue*
Inscr. l.l.: *Le malheureux, que cet aspect
enflamme,/Sent de nouveau s'éveiller dans
son âme/De ses projets l'inquiète fureur;/Il
veut partir, il a vu sans horreur/Qui Pharan
même à sa fuite conspire;/ Près d'elle encore sa
Mère en vain l'attire ; inscr. l.r. : La Mère en
vain fait parler ses douleurs;/Le Fils ingrat,
peu touché de ces pleures,/Sur sa monture
impatient s'élance/Presse sa fuite, à sa famille
en deuil,/Pour tout adieu jette un dernier coup
d'oeil,/Et de Memphis, qu'il voit en
espérance, Urc [?]*
b. *L'enfant prodigue en débauche*
Inscr. l.l.: *Déjà son Bien follement
dispersé/Suffit à peine à son Luxe insensé./Le*

*Jour, la Nuit sous une vaste Tente/Ou l'Or se
mêle à la pourpre éclatante;/Dans ses Banquets
où les Mets somptueux,/Les flots de Vins, les
Chants Voluptueux;* inscr. l.r.: *De tous les
Sens vont allimer l'Audace,/A ses côtés éffron-
tément il place/Et l'Adultère au regard alar-
mé,/Et la débauche, au visage enflammé./A
tous ses Goûts, a toutes ses fureurs/Viennent
offrir des Voluptés cyniques.*
Printed by Robert; published by
Descourtis, Quai de l'Horloge du Palais
No. 63, Paris
Portalis and Beraldi 1: 746
Sterling and Francine Clark Art Institute
Inv. nos. 2343 and 2344

*Prodigal sons in eighteenth-century
popular serials*

12 a–b

William Hogarth (British, 1697–1764)
A Rake's Progress, 1735
Two etchings and engravings, plates 1 and
3 from the set of eight, 355 x 409
a. *A Rake's Progress,* Plate 1
b. *A Rake's Progress,* Plate 3
Published June 1735 by William Hogarth,
London
Paulson 132 and 134
Davison Art Center, Gift of George W.
Davison (B.A. Wesleyan 1892), 1943
1943.D1.108.1 and .3

13 a–b

Richard Purcell (British, ca. 1736–1765)
The Prodigal Son, ca. 1752–55, after
Sébastien Le Clerc II (French, 1676-1763)
Two mezzotints, plates 2 and 5 from the
set of six, 238 x 352
a. *The Prodigal Son Taking Leave*
b. *The Prodigal Son Returns Reclaim'd*
Published by Robert Sayer, Golden Buck
near Sergeant's Inn, Fleet Street, London
Yale Center for British Art, Paul Mellon
Collection
B1970.3.1107 and B1970.3.113

14 a–e

John Raphael Smith (British, 1752–1812)
History of the Prodigal Son, 1775
Five mezzotints with hand coloring,

plates 1, 3–6 from the set of six, each
approx. 255 x 353
a. *The Prodigal Son Receives his Patrimony*
b. *The Prodigal Son in Excess*
c. *The Prodigal Son in Misery*
d. *The Prodigal Son Returns Reclaim'd*
e. *The Prodigal Son Feasted on his Return*
Published 2 January 1775 by Carington
Bowles, 69 St. Paul's Churchyard, London
Yale Center for British Art, Paul Mellon
Collection. B1977.14.11004–11008

15 a–d
Anonymous (British, 18th century)
The Prodigal Son, 1797
Set of four mezzotints, 156 x 117
a. *The Prodigal Son—Taking Leave
of his Father*
Inscr.: *He gathered all together, and took his
Journey into a far Country. /St. Luke
Ch 15. V. 13.*
b. *The Prodigal Son—Revelling with Harlots*
Inscr.: *He wasted his Substance with Riotous
Living. /St. Luke Ch 15. V. 13.*
c. *The Prodigal Son—In Misery*
Inscr.: *He would fain have filled his Belly with
the Husks that Swine did eat/St. Luke
Ch 15. V. 16*
d. *The Prodigal Son—Returned Home
Reclaimed*
Inscr.: *Father I have Sinned against Heaven &
in thy Sight, & am no more worthy to be called
thy Son./St. Luke Ch 15. V. 21.*
Published 12 April 1797 by Laurie &
Whittle, 53 Fleet Street, London
Courtesy of the Print Collection, The
Lewis Walpole Library, Yale University
797/4.12/1–4 (L-A, VII)

Royal prodigals in satiric prints

16
James Gillray (British, 1757–1815)
The Prodigal Son, 1787
Etching with hand coloring, 200 x 148
Published 18 January 1787 by S. W. Fores,
No. 3 Picadilly, London
BM Sat 7129
Yale Center for British Art, Paul Mellon
Collection. B1981.25.935

17
James Gillray (British, 1757–1815)
The Reconciliation, 1804
Etching with hand coloring, 274 x 356
Inscr.: *And he arose and came to his Father,
and his Father saw him, & had compassion, &
ran, & fell on his Neck, & kissed him;* inscr.
u. r. of center: *against heaven and before thee,
and am no more worthy…*
Published 20 November 1804 by H.
Humphrey, 27 St. James's Street, London
BM Sat 10283
Courtesy of the Print Collection, The
Lewis Walpole Library, Yale University
804/11.20/1; Bowditch Collection
966.12.12-9-48

18
Thomas Rowlandson (British, 1756–1827)
The Prodigal Sons [sic] *Resignation*, 1809
Etching with hand coloring, 246 x 349
Inscr. u.l.: *And he arose and went unto
his/Father, and said Father I/have sinned
before thee, and I am no longer worthy to/be
called thy Son.;* inscr. u.r.: *Very Naughty
Boy!—Very/naughty Boy indeed!/however I
forgive you but/don't do so any more.*
Published 24 March 1809 by Thomas
Tegg, No. 111 Cheapside, London
BM Sat 11267
Courtesy of the Print Collection, The
Lewis Walpole Library, Yale University
809/3.24/2

*Eighteenth-century prodigal
daughters*

19 a–f
"Bartolotti" or "Bartoloti"
(English or French, early 19th century)
Laetitia, ca. 1800–20, after George
Morland (English, 1763-1804), in reverse
after John Raphael Smith (English,
1752-1812)
Set of six stipple engravings printed in
color, each approx. 458 x 323 to
500 x 338
a. *Domestic Happiness/Laetitia with
her Parents*
b. *The Elopement /Laetitia seduced from her
Friends under a promise of Marriage*

c. *The Virtuous Parent/Laetitia endeavors in
vain by presents to reconcile her Parents*
d. *Dressing for the Masquerade/Laetitia flies
from reflection to public entertainments*
e. *The Tavern Door/Laetitia deserted by her
Seducer is thrown on the Town*
f. *The Fair Penitent/Laetitia in penitence finds
relief and protection from her Parents*
The Metropolitan Museum of Art, Harris
Brisbane Dick Fund, 1953
53.600.1890 (1–6)

20 a–b
George Quinton (British, b. 1779)
*Magdalen Hospital for the Reception of
Penitent Prostitutes*, 1797, after Thomas
Spence Duché (English, 1763-1790)
a. stipple engraving in oval, printed in
color, first state, 238 x 305 (oval), 305 x
353 (sheet)
Published 24 June 1797 by G. Quinton;
sold by W. Stevenson, Norwich
Lent by David Alexander
b. stipple engraving in oval, printed in
brown, second state, 238 x 305 (oval),
256 x 350 (sheet, trimmed inside
platemark)
Yale Center for British Art,
Paul Mellon Collection. B1977.14.17142

*Nineteenth- and twentieth-century
prodigal sons*

21 a–d
Amos Doolittle (American, 1754–1832)
The Prodigal Son, 1814
Set of four etchings and stipple engravings
with hand coloring, 345 x 252 (sheet)
a. *The Prodigal Son receiving his Patrimony*
Inscr.: *He gathered all together and took his
Journey into a far Country/St. Luke 15
Chap. 13 v*
b. *The Prodigal Son revelling with Harlots*
Inscr.: *He wasted his Substance with Riotous
[sic] Living./St. Luke 15. Chap. 13. v.*
c. *The Prodigal Son in Misery*
Inscr.: *He would fain have filled his Belly with
the husks that the swine did eat./St. Luke 15
Chap. 16 v.*
d. *The Prodigal Son returned to His Father*
Inscr.: *Father I have Sinned against Heaven
and in they sight and am no more worthy to be*

called thy Son/*St. Luke 15 Chap. 21 v.*
Published 24 October 1814 by Shelton &
Kinsett, Cheshire, Connecticut
Shadwell 1969, 110–113
Yale University Art Gallery, Everett V.
Meeks, B.A. 1901, Fund
1993.14.1.1–4

22 a–b
Anonymous (American, 19th century)
The Prodigal Son, ca. 1838–52
Two lithographs with hand coloring,
plates 1 and 3 from the set of four,
356 x 249 (sheet)
a, *The Prodigal Son Receiving His Patrimony*
Inscr.: *A certain man had two sons:—And the
younger of them said to his father, Father, give
me the portion of goods that falleth to me. And
he divi- /ded unto them his living.—And not
many days after, the younger son gathered all
together, and took his journey into a far coun-
try.—/Luke XV. 11.12.13 .*
b. *The Prodigal Son in Misery*
Inscr.: *And he went and joined himself to a
citizen of that Country; and he sent him into
his fields to feed swine. And he would fain
have filled/his belly with the husks that the
swine did eat, and no man gave unto him.—
/Luke XV.15.16.*
Published by Nathaniel Currier, 152
Nassau St. at the corner of Spruce St.,
New York
Currier & Ives 2: 5367 and 5366;
Peters 2243 and 2242
Yale University Art Gallery, The Mabel
Brady Garvan Collection
1946.9.1383–84

23 a–e
James Jacques Joseph Tissot
(French, 1836–1902)
The Prodigal Son, 1881
Set of five etchings and drypoints,
311 x 375
a. Frontispiece
Inscr. on pages of an open Bible with pas-
sages from the parable (cited below) under
chapter headings: *No. 1/The Departure/
No. II/In Foreign Climes/ No. III/
The Return/No. IV/The Fatted Calf*
b. *No. 1/The Departure*
Inscr. l.l.: *V. 11 And he said. A certain man
had two sons:/V. 12 And the younger of them*

said to his; inscr. l.r.: *father, Father, give me
the portion of/goods that falleth to me. And he
divided/unto them his living.*
c. *No. II/In Foreign Climes*
Inscr. l.l.: *V. 13 And not many days after the
younger/son gathered all together, and took his
journey;* inscr. l.r.: *into a far country, and
there wasted his/substance with riotous living.*
d. *No, III/The Return*
Inscr. l.l.: *V. 16 And he would fain have filled
his belly with the/husks that the swine did eat:
and no man gave unto him./V. 17 And when
he came to himself, he said. How many/hired
servants of my father's have bread enough and
to/spare, and I perish with hunger!;* inscr. l.r.:
*I will arise and go to my father, and will say
unto/him. Father, I have sinned against heav-
en, and before thee./V. 20 And he arose, and
came to his father. But when he/was a great
way off, his father saw him and had/compas-
sion, and ran, and fell on his neck,
and kissed him.*
e. *No. IV/The Fatted Calf*
Inscr. l.l.: *V. 29 And he answering said to his
father, Lo, these many/years do I serve thee,
neither transgressed I at any time/thy com-
mandment: and yet thou never gavest me a kid,
that/I might make merry with my friends:/V.
30 But as soon as this thy son was come which
have devoured;* inscr. l.r.: *thy living with har-
lots, thou hast killed for him the fatted calf./V.
31 And he said unto him, Son, thou art ever
with me, and/all that I have is thine./V.32 It
was meet that we should make merry and be
glad for this/thy brother was dead, and is alive
again; and was lost, and is found.*
Wentworth 57–61
Yale University Art Gallery, Gift of
G. Allen Smith. 1977.6.15a–e

24
William Strang (Scottish, 1859–1921)
The Penitence of the Prodigal Son, 1882
Etching, 175 x 200
Binyon 10
Davison Art Center, Friends of the
Davison Art Center funds, 1982
1982.27.1

25
Alphonse Legros (French, 1837–1911)
The Prodigal Son Among Swine, 2nd plate,
ca. 1870–90
Drypoint, 228 x 150
Poulet-Malassi & Thibaudeau 293
Yale University Art Gallery, The Walter
R. Callender, B.A. 1894, Memorial
Collection, Gift of Ivy Lee Callender
1962.45.300

26
Jean-Louis Forain (French, 1852–1931)
Return of the Prodigal Son, 1909
Etching, 289 x 218
Faxon 57 ii/ii, trial proof; Guerin 46
Yale University Art Gallery, Gift of
G. Allen Smith. 1972.12.5

27
Jules Pascin (Julius Pinkas, American,
b. Bulgaria, 1885–1930)
*The Prodigal Son Among the Harlots
(L'Enfant prodigue chez les filles)*, 1926
Drypoint, 335 x 478
Hemin, Krohg, Perls, and Rambert 133;
Dubreuil 30
Davison Art Center, Friends of the
Davison Art Center funds, 1982
1982.26.1

28
Thomas Hart Benton
(American, 1889–1975)
Return of the Prodigal Son, 1939
Lithograph, 258 x 336 (image),
300 x 460 (sheet)
Fath 29
Davison Art Center, Gift of
Mr. and Mrs. Louis Mink, 1982
1982.44.1

29 a–e
Duane Michals (American, b. 1932)
The Return of the Prodigal Son, 1982
Set of five gelatin silver prints,
each 127 x 177
Davison Art Center, Samuel L. Silipo
(B.A. Wesleyan 1985) Memorial Fund
1994.4.1 a–e

Selected Bibliography

Adhémar, Jean. *Imagerie populaire française*. Milan: Electa, 1968.

Armstrong, Christine Megan. *The Moralizing Prints of Cornelis Anthonisz*. Princeton: Princeton University Press, 1990.

Baron, Frank, ed. *Rilke and the Visual Arts*. Lawrence, Kansas: Coronado Press, 1982.

Baldwin, Robert W. "A Bibliography of the Prodigal Son Theme in Art and Literature." *Bulletin of Bibliography* 44 (September 1987): 167–71.

Bartsch, Adam von. *Le Peintre graveur*. 21 vols. Vienna: J. V. Degen, 1803–21.

————. *The Illustrated Bartsch*. 84 vols to date. New York: Abaris Books, 1978–.

Bellini, Paolo. *L'Opera Incisa di Pietro Testa*. Vicenza: N. Pozza, 1976.

Bergström, Ingvar. "Rembrandt's Double-Portrait of Himself and Saskia at the Dresden Gallery." *Nederlands Kunsthistorische Jaarboek* 17 (1966): 143–69.

Binyon, Lawrence. *William Strang: Catalogue of His Etched Work, 1882–1912*. Glascow: James Maclehose and Sons, 1912.

Blum, André. *L'oeuvre gravé d'Abraham Bosse*. 2 vols. Paris: Editions Albert Morancé, 1924.

Bowles and Carver's New and Enlarged Catalogue. London: Bowles and Carver, 1795.

British Museum Catalogue of . . . Political and Personal Satires. 2 vols. London: British Museum, 1873–83.

Brookner, Anita. *Greuze: The Rise and Fall of an Eighteenth-Century Phenomenon*. Greenwich, Conn.: New York Graphic Society, 1972.

Brown, Milton. "From Salon to Saloon." *Parnassus* 13 (May 1941): 193–94.

Campbell, Colin. "Rembrandt's 'Polish Rider' and the Prodigal Son." *Journal of the Warburg and Courtauld Institutes* 33 (1970): 292–303.

Carington Bowles' New and Enlarged Catalogue. London: Carington Bowles, 1784.

Cropper, Elizabeth. *Pietro Testa 1612–1650: Prints and Drawings*. Philadelphia: Philadelphia Museum of Art, 1988.

Currier & Ives: A Catalogue Raisonné. 2 vols. Detroit: Gale Research Company, 1984.

D'Oench, Ellen G. "Prodigal Sons and Fair Penitents: Transformations in Eighteenth-Century Popular Prints." *Art History* 13 (September 1990): 318–43.

Fath, Creekmore. *The Lithographs of Thomas Hart Benton*. Austin & London: University of Texas Press, 1979.

Faxon, Alicia Craig. *Jean-Louis Forain: A Catalogue Raisonné of the Prints*. New York & London: Garland Publishing Inc., 1982.

Fliegelman, Jay. *Prodigals and Pilgrims: The American Revolution Against Patriarchal Authority, 1750–1800*. Cambridge and New York: Cambridge University Press, 1982.

Franklin, Colin, and Charlotte Franklin. *A Catalogue of Early Colour Printing*. Culham, Oxford: Home Farm, 1977.

Gambone, Robert. *Art and Popular Religion in Evangelical America, 1915–1940*. Knoxville: University of Tennessee Press, 1989.

Gaunt, William. *The Etchings of Frank Brangwyn, R. A.* London: The Studio, Limited, 1926.

Gide, André. *The Return of the Prodigal Son*. Translated by Wallace Fowlie. In *The André Gide Reader*. Edited by David Littlejohn. New York: Alfred A. Knopf, 1971.

Goddard, Stephen H. *The World in Miniature: Engravings by the German Little Masters 1500–1550*. Lawrence, Kansas: Spencer Museum of Art, 1988.

Godfrey, Richard, and John Riely. *English Caricature 1620 to the Present*. London: Victoria and Albert Museum, 1984.

Guiffrey, J.-J. *L'Oeuvre de Ch. Jacque*. Paris: Mlle. Lemaire, Editeur, 1866.

Guérin, Marcel. *J.-L. Forain Aquafortiste*. 1912. Reprint. San Francisco: Alan Wofsy Fine Arts, 1980.

Haeger, Barbara Joan. "The Prodigal Son in Sixteenth- and Seventeenth-Century Netherlandish Art: Depictions of the Parable and the Evolution of a Catholic Image." *Simiolus* 16 (1986): 128–38.

————. "The Religious Significance of Rembrandt's 'Return of the Prodigal Son': An Examination in the Context of the Visual and Iconographic Tradition." Ph.D. diss., University of Michigan, Ann Arbor, 1983.

Harbison, Craig. *Symbols in Transformation: Iconographic Themes at the Time of the Reformation*. Princeton: The Art Museum, Princeton University, 1969.

Haskins, Susan. *Mary Magdalen: Myth and Metaphor*. New York: Harcourt Brace & Company, 1993.

Hemin, Yves, Guy Krohg, Klaus Perls, and Abel Rambert. *Pascin: Catalogue Raisonné*. Paris: Editions Abel Rambert, 1990.

Hollstein, F. W. H. et al. *Dutch and Flemish Etchings, Engravings, and Woodcuts, ca. 1450–1700*. 43 vols to date. Amsterdam: Menno Hertzberger, 1949–.

———. *German Engravings, Etchings, and Woodcuts, ca. 1400–1700*. 36 vols to date. Amsterdam: Menno Hertzberger, 1954–.

Jacobowitz, Ellen S., and Stephanie Loeb Stepanek. *The Prints of Lucas Van Leyden & His Contemporaries*. Washington, D. C.: National Gallery of Art, 1983.

Kozloff, Max. *Duane Michals: Now Becoming Then*. Altadena, Calif.: Twin Palms Publishers, 1990.

Kunzle, David. *The Early Comic Strip: Narrative Strips and Picture Stories in the European Broadsheet from c. 1450 to 1825*. Vol 1. Berkeley: University of California Press, 1973.

———. "Plagiaries-by-Memory of the 'Rake's Progress'." *Journal of the Warburg and Courtauld Institutes* 29 (1966): 311–20.

Kurz, Hilda. "Italian Models of Hogarth's Picture Stories." *Journal of the Warburg and Courtauld Institutes* 15 (1952): 136–65.

Leppert, Richard. "The Prodigal Son: Teniers and Ghezzi." *The Minneapolis Institute of Arts Bulletin* 61 (1974): 81–91.

Lieure, Jules. *Jacques Callot: Catalogue de l'oeuvre gravé*. 3 vols. Paris: Editions de la Gazette des Beaux-Arts, 1924–27.

The Lotus Sutra. Translated by Burton Watson. New York: Columbia University Press, 1993.

Matyjaszkiewicz, Krystyna, ed. *James Tissot*. London: Phaidon Press and Barbican Art Gallery, 1984.

Nagler, G. K. *Neues allgemeines Künstler-Lexikon*. 22 vols. Munich: E. A. Fleischmann, 1835–52.

Nochlin, Linda. "Lost and 'Found': Once More the Fallen Woman." *Art Bulletin* 60 (March 1978): 139–53.

Panofsky, Erwin. *The Life and Art of Albrecht Dürer*. Princeton: Princeton University Press, 1971.

Pauli, Gustav. *Hans Sebald Beham*. Strasbourg: J. H. Ed. Heitz, 1901.

Paulson, Ronald. *Hogarth's Graphic Works*. 2 vols. New Haven: Yale University Press, 1970.

Peters, Harry T. *Currier & Ives: Printmakers to the American People*. 2 vols. Garden City: Doubleday, Doran & Company, Inc., 1931.

Portalis, Roger, and Henri Beraldi. *Les graveurs du dix-huitième siècle*. 3 vols. Paris: Damascène Morgand et Charles Fatout, 1880–82.

Poulet-Malassi, A., and A.-W. Thibaudeau. *Catalogue raisonné de l'oeuvre gravé et lithographié de M. Alphonse Legros*. Paris: J. Baur, 1877.

Rilke, Rainer Maria. *The Notebooks of Malte Laurids Brigge*. Translated by M. D. Herter Norton. In *Rainer Maria Rilke: Prose and Poetry*. Edited by Egon Schwarz. New York: Continuum, 1984.

Robert-Dumesnil, A.-P.-F. *Le peintre-graveur français*. 2 vols. Paris: Gabriel Warée, Mme Huzard et al, 1835–71.

Rosenblum, Robert. *Transformations in Late Eighteenth-Century Art*. Princeton: Princeton University Press, 1970.

Sayer and Bennetts Enlarged Catalogue of New and Valuable Prints. 1775. Reprint. London: Holland Press, 1970.

Shadwell, Wendy J. et al. *American Printmaking: The First 150 Years*. Washington, D. C.: Smithsonian Institution Press, 1969.

Singer, Hans W. "Der Vierfarbendruck in der Gefolgschaft Jacob Christoffel le Blons." *Monatschaft für Kunstwissenschaft* 10 (1917): 177–99.

Smith, John Raphael. "A Catalogue of Prints." [ca. 1797]. Department of Prints and Drawings, British Museum.

Stechow, Wolfgang. "'Lusus Laetitiaeque Modus'." *Art Quarterly* 35 (1972): 165–75.

Steinway, Kate. "The Kelloggs of Hartford: Connecticut's Currier & Ives." *Imprint, The Journal of the American Historical Print Collectors' Society* 13 (Spring 1988): 2–12.

Sutton, Peter et al. *Masters of Seventeenth-Century Dutch Genre Painting*. Philadelphia: Philadelphia Museum of Art, 1984.

Taggard, Mindy Nancarrow. *Murillo's Allegories of Salvation and Triumph: 'The Parable of the Prodigal Son' and 'The Life of Jacob'*. Columbia and London: University of Missouri Press, 1992.

Vetter, Ewald. *Der Verlorene Sohn*. Dusseldorf: L. Schwann, 1955.

Wentworth, Michael Justin. *James Tissot*. Oxford: Clarendon Press, 1984.

———. *James Tissot: Catalogue Raisonné of His Prints*. Minneapolis: The Minneapolis Institute of Arts, 1978.

White, Christopher, and Karel G. Boon. *Rembrandt's Etchings*. 2 vols. Amsterdam: Van Gendt & Co., 1969.

Witwitzky, Willibald. "Das Gelichnis vom verlorenen Sohn in der bildeneden Kunst bis Rembrandt." Ph.D. diss., Ruprecht-Karls Universität, Heidelberg, 1930.

Wolf, Edwin, 2nd. "The Prodigal Son in England and America: A Century of Change." In *Eighteenth-Century Prints in Colonial America*, ed. Joan D. Dolmetsch, 145–74. Williamsburg: The Colonial Williamsburg Foundation, 1979.

Wüthrich, Lukas Heinrich. *Das druckgraphische Werk von Matthäeus Merian*. 2 vols. Basel: Bärenreiter Verlag, 1972.

Young, Alan R. *The English Prodigal Son Plays: A Theatrical Fashion of the Sixteenth and Seventeenth Centuries*. Salzburg: Institut für Anglistik und Amerikanaistik Universität, 1979.

Photography credits:

Courtesy British Museum (Figs. 2, 3, 4)
Cathy Carver (No. 3 a–d)
Richard Caspole, Yale Center for British Art
(No. 14, a, c–f; 20 b)
Courtesy Sterling and Francine Clark Art
Institute (No. 9 a–d, 11 a–b)
Courtesy David Alexander (No. 20 a)
George E. Landis (Nos. 1, 7, 10)
Courtesy of the Print Collection, The Lewis
Walpole Library, Yale University (No. 17)
Courtesy The Library Company of Philadelphia
(No. 14 b)
Courtesy The Museum of Fine Arts,
Boston (Fig. 1)
Courtesy The Museum of Modern Art (Fig. 5)
Charlotte F. Phil (Nos. 5, 12 a, 24, 29, 29 a–e)
Yale University Art Gallery (Nos. 1, 21 a–d,
23 a–e, 26)

Design: Sloan Wilson
Printing: Van Dyck Columbia